Ohio
Presidents

Ohio Presidents

A Whig and Seven Republicans

DALE THOMAS

AMERICA
THROUGH TIME®
ADDING COLOR TO AMERICAN HISTORY

America Through Time is an imprint of Fonthill Media LLC
www.through-time.com
office@through-time.com

Published by Arcadia Publishing by arrangement with Fonthill Media LLC
For all general information, please contact Arcadia Publishing:
Telephone: 843-853-2070
Fax: 843-853-0044
E-mail: sales@arcadiapublishing.com
For customer service and orders:
Toll-Free 1-888-313-2665

www.arcadiapublishing.com

First published 2019

ISBN 978-1-63499-116-2

Typeset in Sabon
Printed and bound in England

Acknowledgements

Lea Thomas proofread the text and offered suggestions. Geoffrey and Scot Thomas helped with problems about computer hardware and software. Pictures are from the Library of Congress unless otherwise noted.

Cover picture: Puck magazine satirized the tariff controversy on October 21, 1896: "We are not a nation of swindlers!" Holding a flag, William McKinley stood between Benjamin Harrison and Grover Cleveland. A Democrat from New York, Pres. Cleveland opposed a high protective tariff. (*Library of Congress*)

Contents

Introduction

EIGHT PRESIDENTS HAVE ROOTS IN OHIO, where today these communities take pride in their heritage. William Henry Harrison, a Whig, served the shortest period of time as any president, but his legacy is the campaign strategy of 1840. Northern Whigs formed the Republican Party in 1854. After the Civil War, Ohio became a swing state for the party in presidential elections.

Ulysses S. Grant's exceptional leadership in the Civil War contrasted with his problems as president. Rutherford B. Hayes ended Reconstruction policies but could not protect the civil rights of African Americans in the South. James A. Garfield died from a gunshot fired by a disappointed office seeker. His death led to the first civil service laws. Benjamin Harrison's administration included the modernizing of the U.S. Navy.

William McKinley won election to the White House campaigning for the gold standard and high tariffs. He led the nation into its first military intervention overseas during the Spanish American War. His assassination by an anarchist made Theodore Roosevelt the youngest president in history.

Roosevelt chose William H. Taft to succeed him as president. Soon after his election, Taft displeased Roosevelt for being too conservative. In spite of scandals in his administration, Warren G. Harding had important accomplishments in foreign and domestic affairs.

The American Political Science Association in 2018 rated the presidents. Except for William Henry Harrison, those from Ohio were listed from best to worst: William McKinley, Ulysses S. Grant, William H. Taft, Rutherford B. Hayes, Benjamin Harrison, James A. Garfield, and Warren G. Harding.

A history of these eight presidents illustrates that many of the same controversies face the nation today. Differences of opinion include the problem of government corruption, high tariffs, immigration restriction, minority rights, foreign intervention, and internal terrorism. As in the past, success or failure in dealing with these issues can only be judged in the long run of history. From 1804 to 2016, Ohio voted in fifty-four presidential elections and forty-four times selected the winning candidate. The last time the state voted for the loser came in 1960 when John F. Kennedy defeated Richard M. Nixon.

William Henry Harrison

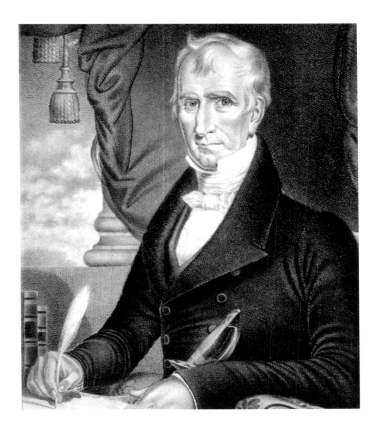

William Henry Harrison, the ninth president, held office from March 4 to April 4, 1841. Due to his brief tenure in the White House, historians do not usually rank Harrison among the nation's presidents. Besides serving the shortest time of any president, he remained the oldest elected president until Ronald Reagan in 1981.

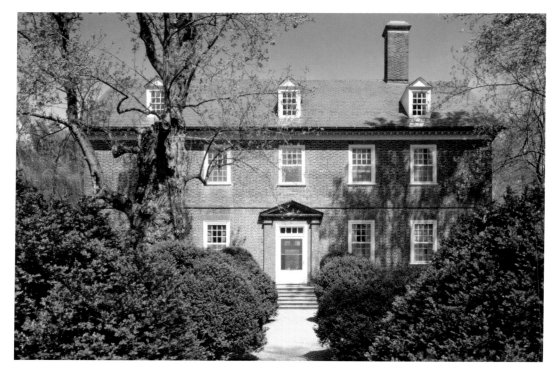

Harrison was born on February 9, 1773 on Berkeley plantation in the British colony of Virginia. His father, Benjamin Harrison V, served in the Continental Congress and signed the Declaration of Independence. Tutored at home, he went on to study the classics at Hampden-Sydney in Virginia and later medicine at the University of Pennsylvania. The death of his father left the eighteen-year-old with financial problems, and he decided on a military career, helped along by family connections.

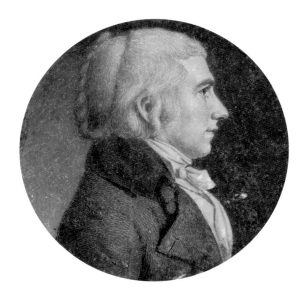

The engraved print shows Harrison in 1800, when serving in the House of Representatives from the Northwest Territory. He had gone to the region in 1791 and soon became Maj.-Gen. Anthony Wayne's *aide-de-camp*. The lieutenant fought in the Battle of Fallen Timbers. Sometime in the past, a tornado toppled the trees, which Wayne's forces used for protection during the fighting. The victory over the Native Americans led to the 1795 Treaty of Greenville, which opened for settlement two-thirds of today's Ohio.

Right: At North Bend, Ohio, in November 1795, Harrison married Anna Tuthill Symmes without the approval of her father. Judge John Symmes thought Harrison could not adequately support his daughter with a military salary. Symmes later sold him a farm of 160 acres in North Bend, which overlooked the Ohio River. The couple had ten children, leading to health problems for Anna, but she survived her husband by twenty-three years.

Below: Two years after Harrison resigned from the army, Pres. John Adams appointed him to be the first governor of Indiana Territory in 1800. He moved to the new capital of Vincennes, where his restored home and farm is today a tourist attraction. Gov. Harrison wanted to encourage settlers from the South by legalizing slavery. Pres. Thomas Jefferson refused to support a change in the Northwest Ordinance of 1787 that prohibited slavery in the region.

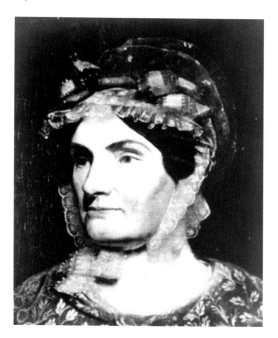

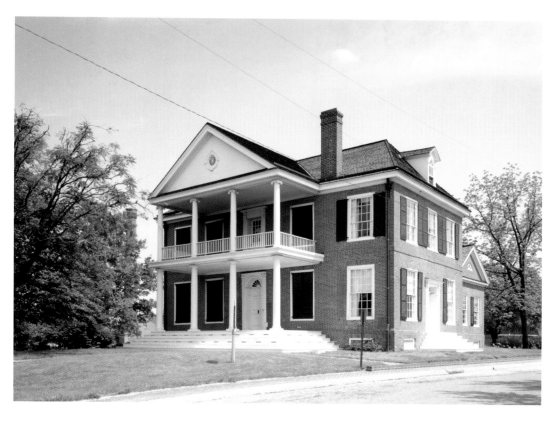

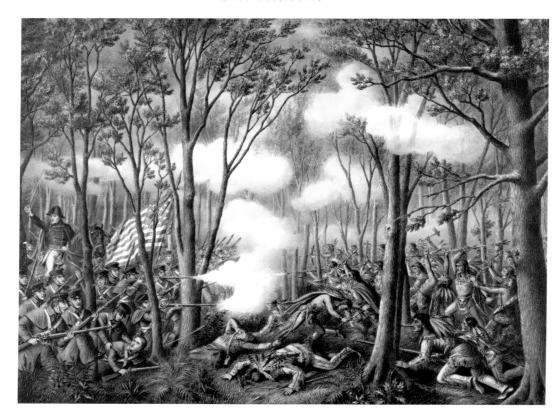

Above: Angry over the cession of land for white settlers, Tenskwatawa led a force of Native Americans into the disputed region along the Tippecanoe River near the present city of Lafayette, Indiana. With the support of the British in Canada, his brother Tecumseh had tried to form a confederation of tribes between the Ohio River and the Great Lakes. Gov. Harrison with militiamen and regular soldiers defeated Tenskwatawa in November 1811. Harrison quickly gained a national reputation and a nickname: "Tippecanoe."

Left: Tecumseh was born in March 1768 at Old Chillicothe in the Ohio Country of the British Empire. An eloquent orator, he became chief of the Shawnee in 1789 and dedicated his life to uniting Native American resistance against the United States Government seizing their ancestral lands. His warriors helped the British capture Detroit in August 1812, but they failed to take forts in northwestern Ohio. He was known to have saved the lives of captured American soldiers. The dream of tribal unity died with Tecumseh during the Battle of the Thames.

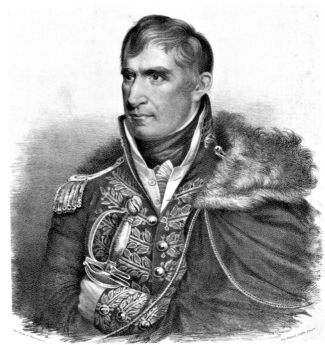

Harrison became a major-general during the War of 1812. He first went on the defensive by building Fort Meigs on the Maumee River in western Ohio. Then he recaptured Detroit and invaded Canada, defeating the British forces at the Battle of the Thames on October 5, 1813. Along with Cdr. Oliver Perry's victory in the Battle of Lake Erie, Gen. Harrison's successful campaign secured the Northwest from any further British and Native American threats. He returned to civilian life and his farm at North Bend in 1814.

From 1816 to 1819, Harrison served in the House of Representatives, declining to be Pres. Monroe's Secretary of War in 1817. He won election to the U.S. Senate in 1824 then resigned four years later to become the Minister to Colombia. Pres. Jackson recalled him to make his own appointment in 1829. He continued to farm his land on the Ohio River, growing corn and distilling whiskey until realizing the evil effects on consumers. A number of books about him contributed to his status as a national hero. He became a close friend of George DeBaptiste, an African American and Underground Railroad conductor. In 1836, he ran for president along with three other Whigs and lost to the Democrat Vice Pres. Martin Van Buren.

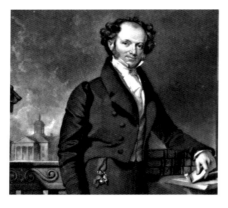

A cofounder of the Democratic Party, Martin Van Buren was born of Dutch-American parents in Kinderhook, New York on December 5, 1782. Unlike Harrison, he had little formal education and became a self-taught lawyer, which was not uncommon at the time. Before becoming Jackson's vice president, Van Buren's public service included New York Governor, U.S. Senator, Secretary of State, and Minister to the United Kingdom. In the election of 1848, he received 10 percent of the popular vote as a candidate for the Free Soil Party, which opposed the spread of slavery into the territories.

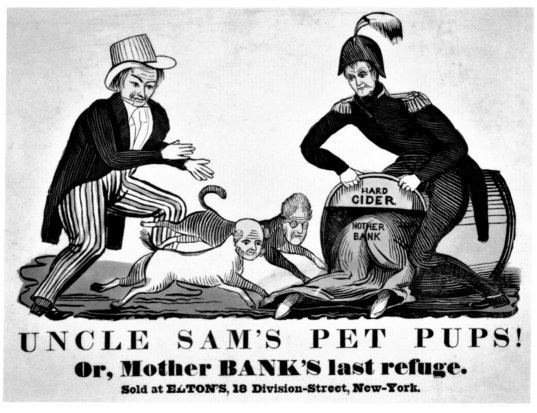

A mythical character, Jack Downing chases Jackson and Van Buren after "Mother Bank," who is crawling into a hard cider barrel held open by Harrison. Running for president in 1840, Harrison supported the re-establishment of the Bank of the United States, which Jackson and Van Buren believed to be a rich man's monopoly. As a Whig, he saw the bank as a monetary-stabilizing institution promoting the economic development of the nation. Democrats preferred a subtreasury policy where federal tax revenue was deposited in numerous banks, "Pet Banks" according to Whig critics. The term "OK" may have originated during the election from supporters of Van Buren who called him "Old Kinderhook."

Andrew Jackson left the presidency in March 1837, but he continued to influence the basic Democratic principle of stronger state governments and a weak central government. However, he did not support South Carolina's attempt to nullify a tariff in 1831. He was credited as the founder of the spoils system, replacing government workers with his own appointees. He also used his veto power like no president before him. Opposition to Pres. Jackson led to the formation of the Whig Party. Whig was a word borrowed from the British government for those opposing a strong monarchy. Critics called him "King Andrew."

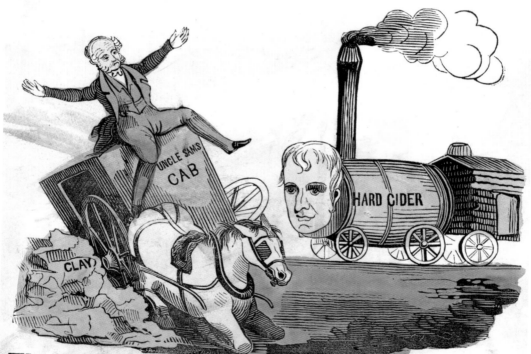

The People's Line--Take care of the Locomotive
Sold at 104 Nassau, and 18 Division Streets, New-York.

"Tippecanoe and Tyler too" became the slogan for Harrison's presidential campaign in 1840. Democrats said a senile Harrison should be given a barrel of hard cider and a pension so he could retire to his log cabin. The Whigs used the insult to portray their candidate as a man of the people, who was born in a log cabin. In contrast, Pres. Van Buren represented the wealthy. A prominent Whig, Henry Clay upended the president, blaming him for the depression. Harrison won the election with nearly 80 percent of the electoral vote, the first Whig to become president. In contrast to his campaign image, he wanted the nation to know his true background as a well-educated and successful general and farmer.

In early 1841, Harrison and his family left North Bend in horse-drawn carriages on their journey to Washington. Anna Harrison did not go with her husband because of an illness. He first visited a daughter in Virginia, and then Harrison became the first president-elect to travel by train for his inauguration. John Harrison rode with his family, the only son and father of a president. He served in Congress and died in 1878. Interred in the family tomb at North Bend, his body was stolen by grave robbers for a medical college in Cincinnati. Outraged, his son returned it to the vault.

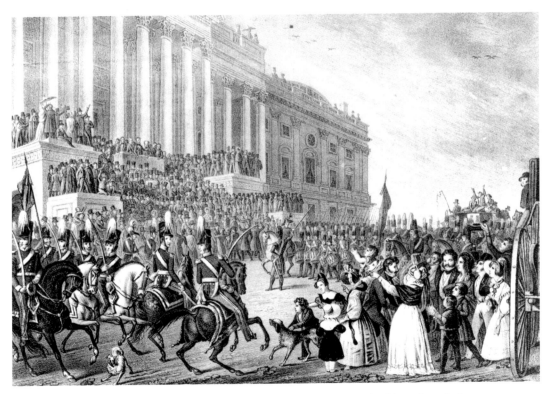

Although Daniel Webster edited the speech, Pres. Harrison's inaugural address lasted almost two hours, the longest in history. He called for the re-establishment of the Bank of the United States and promised to curtail the use of his veto power along with a reversal of the spoils system. Perhaps to display his physical fitness, he refused to wear a hat or an overcoat in spite of the wet and cold weather of March 4, 1841. Afterwards in the parade, he rode on horseback instead of a closed carriage and then attended three inauguration balls.

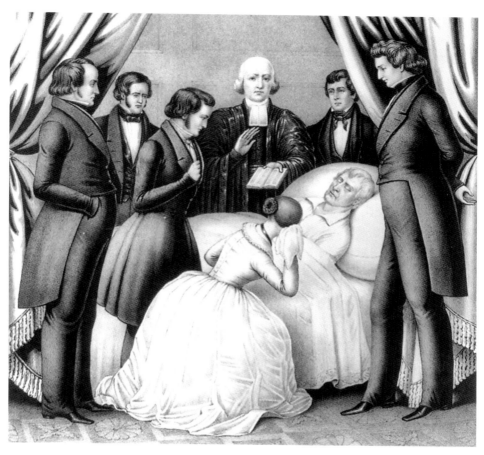

Harrison fell ill three weeks after being sworn in as the ninth president. Trying to rest in the White House, he could not find a quiet place to sleep due to the office seekers. Primitive remedies from doctors made his condition worse, and he died on April 4, 1841. At the time, his death was attributed to pneumonia but a study in 2014 concluded the cause to be an infection from the drinking water contaminated by public sewage. A group of mourners gather around the president: from left to right: Daniel Webster, Secretary of State; Thomas Ewing, Secretary of Treasury; Dr. Miller; niece; Rev. Hawley; nephew; Francis Granger, postmaster general.

John Tyler was the first vice president to take office after the death of a president. He established the tradition of being the legitimate president and not an acting one. A Virginian, Tyler favored more the agenda of Van Buren and Jackson. Whigs wanted him on the ballot to attract more voters. He vetoed Whig legislation, refusing the advice of Daniel Webster and Henry Clay. They expelled "His Accidentcy" from the Whig Party. Tyler wanted to run for president in 1844, but he lacked the support from either party.

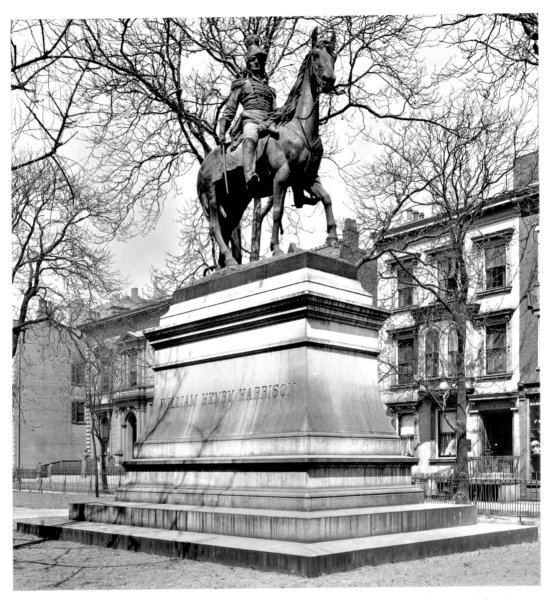

The equestrian monument of Gen. William Henry Harrison stands in downtown Cincinnati. Louis T. Rebisso of the Cincinnati School of Design created the statue. The dedication took place in 1896, eighty-five years after the Battle of Tippecanoe. In the meantime, only 16 miles from the city, Harrison's tomb at North Bend needed attention after years of neglect. The State of Ohio finally bought the land from Harrison's heirs and completed a restoration and enlargement of the site in 1922.

2

Ulysses S. Grant

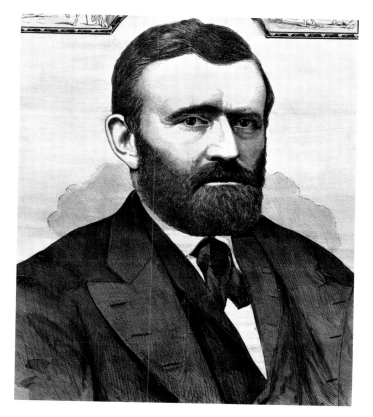

Ulysses S. Grant, the eighteenth president, held office from March 1869 to March 1877. The American Political Science Association in 2018 gave him a rating of 52.9 percent, placing him at twenty-first of the forty-three presidents and second among those from Ohio.

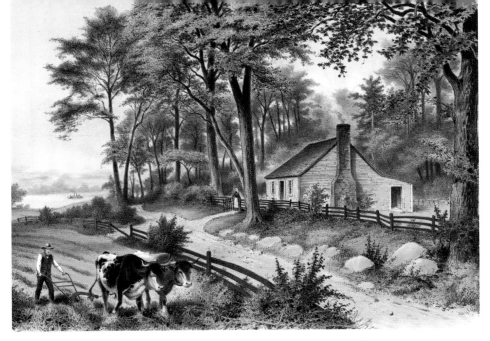

Above: Hiram Ulysses Grant was born at Point Pleasant, Ohio on April 27, 1822. To promote Grant's candidacy for president, this idyllic picture shows the farm where he lived for only a year. Jesse Root Grant, his father, came to Ohio at the age of five in 1789 and, while a young man, served apprenticeships as a tanner. After acquiring his own tannery, he married Hannah Simpson. An abolitionist and a Whig, Jesse thought religion besides education should be of equal importance to his family, and he helped found the Georgetown Methodist Church. Jesse served as the mayor of Georgetown and later Bethel in Ohio.

Below: Jesse Grant moved his family to a home he built at Georgetown in 1823. Restored and open to the public in 1982, the house stands on the original site at 219 Grant Avenue. Ulysses lived here longer than any other home until going to West Point in 1839. Not wanting to be a tanner, he attended Mayville Seminary and Rankin Academy. Unlike the rest of the family, he rarely attended church and may have been agnostic throughout his life.

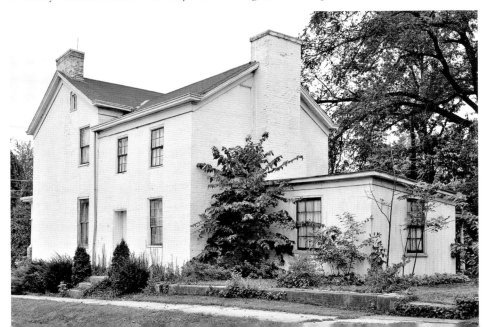

Through the efforts of his father, Grant received an appointment to the United States Military Academy at West Point. He registered as Ulysses S. Grant because of a clerical error and assumed the name. At first, he disliked the military way of life and even thought of leaving the academy but soon adapted to the routine. He sometimes neglected his academic studies, spending time reading historical novels and taking art lessons. His horsemanship won many awards. A future Confederate general, James A. Longstreet was among his few friends, along with Frederick Tracy Dent. Ranking twenty-one out thirty-nine in his class, Lt. Grant graduated in 1843 and originally planned to resign after the required four years in the army.

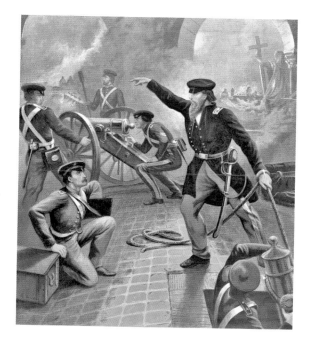

In September 1847, outside of Mexico City at San Cosme, Grant commanded soldiers who fired a howitzer from a church against attacking Mexicans. With Pres. John Tyler's annexation of Texas in 1845, tension with Mexico had increased, leading to Pres. James K. Polk asking Congress for a declaration of war in 1846. Grant disapproved of the Mexican War, seeing it as an unjust attack against a weaker country and a land grab to expand slavery. However, he fought bravely and received a promotion to a brevet captain in the conflict, learning the tactics and strategies used later in the Civil War.

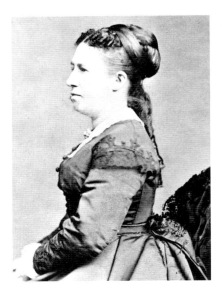

Left: While stationed at the Jefferson Barracks near St. Louis, Grant met Julia Dent, sister of his friend at West Point. They married in August 1848 with her cousin Longstreet in the groom's party. Grant's parents refused to attend the wedding because the Dent family owned slaves but affectionately received Julia in Bethel, Ohio.

Below: Not pleased with his commanders, Grant also had concerns about adequately supporting his family. He resigned from the army in 1854 but had numerous problems with failed business ventures. Two years later, outside of St. Louis, he farmed and built a cabin on land owned by his father-in-law. Julia hated the place that her husband called "Hard Scrabble." After an attack of malaria, he stopped farming and moved his family to the Dent plantation. Julia's father gave him a slave, but Grant freed William Jones instead of selling him to pay his debts. In April 1860, he accepted an offer to work in his father's leather goods store in Galena, Illinois.

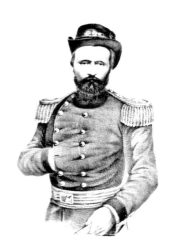

At the outbreak of the Civil War in 1861, Grant recruited volunteers for Illinois regiments. Congressman Elihu Washburne helped Grant's promotion to brigadier general. On February 6, 1862, he easily captured Fort Henry in Tennessee and then ten days later won a hard-fought battle at Fort Donelson, the first major victory for the Union in the war. His superior officer, Gen. Henry Halleck complained that Grant disobeyed orders before attacking the Confederates. Using his initials, newspapers in the North called him "Unconditional Surrender Grant."

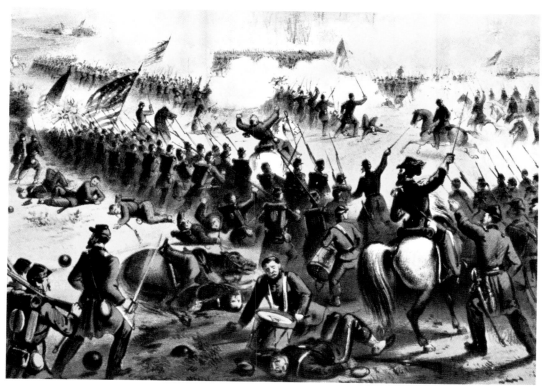

In early April 1862, Gen. Grant nearly lost a battle at Shiloh in southwestern Tennessee. He rallied his army on the second day with the help of Gen. William T. Sherman and defeated the Confederates in what was then the costliest battle in American history. The Northern press criticized him with rumors of his drunkenness. Gen. Halleck relieved him as field commander of the Army of the Tennessee, but Pres. Lincoln reinstated him. Grant then defeated the Confederates around Corinth, Mississippi. After Lincoln's preliminary Emancipation Proclamation, Grant ordered his officers to accept the former slaves as soldiers in the Union Army.

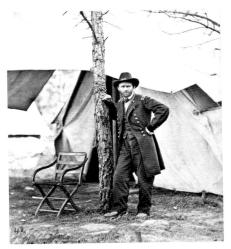

Grant stood next to his tent outside of Cold Harbor, Virginia, in June 1864. In his memoirs, he regretted ordering two failed frontal assaults at Cold Harbor and Vicksburg. Grant's victory at Vicksburg, Mississippi in July 1863 resulted in his promotion to major-general. Opposing a West Point friend and Julia Grant's cousin, he fought Gen. Longstreet and the Confederate Army under Gen. Braxton Bragg in Chattanooga, Tennessee. The campaign lasted two months and ended in a victory on November 25, 1863. Gen. Sherman took over the Western District, and Grant, now a lieutenant general, became head of the entire Union Army, directing the eastern campaign in March 1864.

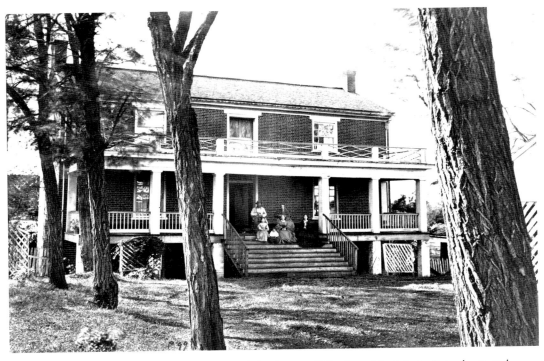

After Cold Harbor, Gen. Robert E. Lee moved the Army of Northern Virginia to Petersburg and defended the railroad-supply route into Richmond. Grant ordered the construction of fortified trenches around the Confederate position. The Siege of Petersburg lasted from June 9, 1864 to March 25, 1865. Union troops finally penetrated the enemy defenses, forcing the Confederate army to retreat toward Appomattox County. Outnumbered and poorly supplied, Lee decided to capitulate. He surrendered to Grant in Wilmer McLean's house at Appomattox Courthouse on April 9, 1865. Ironically in 1861, McLean had witnessed the first major Civil War battle at Manassas, Virginia and moved to this apparently peaceful county.

In August 1867, Grant served six months as the acting Secretary of War as well as commanding the U.S. Army. Pres. Andrew Johnson appointed him to his cabinet after suspending Sec. Edwin Stanton. A Radical Republican, Stanton clashed with the president over the policies regarding the former Confederate states. A Democrat and military governor of Tennessee, Johnson ran with Lincoln on the National Union ballot in 1864. He supported a moderate Reconstruction plan for the South. At odds with the President, Grant later resigned after Congress overruled Johnson's actions against Stanton. Out of moral but mostly political motivation, Grant and the Radical Republicans wanted to guarantee the voting rights for African Americans in the South to maintain control of the federal government.

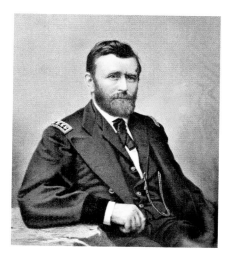

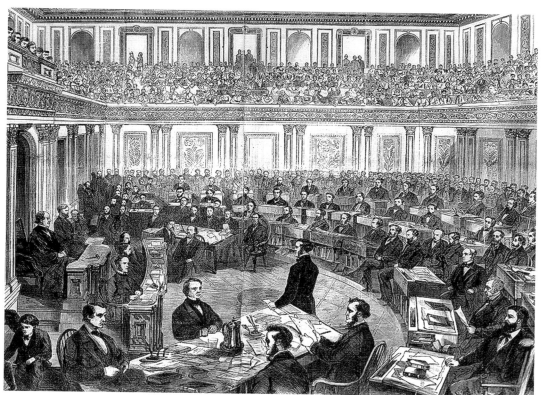

On February 24, 1868, the House of Representatives impeached Pres. Johnson on eleven articles including his violation of the Tenure of Office Act since he had suspended Sec. Stanton without the Senate's approval. Chief Justice of the Supreme Court Salmon P. Chase presided during the Senate trial that started on March 4. Three Senate roll calls in May fell short by one vote of the two-thirds majority needed for conviction. Voting not guilty, three Republicans never again served in elected office.

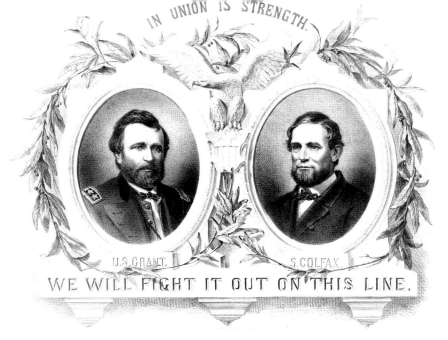

Above: Grant's war record and opposition to Pres. Johnson led to his nomination and victory in the 1868 presidential election. "Waving the Bloody Shirt," Republicans blamed the Democrats for causing the Civil War. Schuyler Colfax of Indiana ran as vice president, thinking Grant would only serve one term. The Hoosier unwisely declared that he would not run for that office again with plans of seeking the nomination for president in 1872. He changed his mind but lost out to Henry Wilson, and then the Crédit Mobilier scandal doomed his future in politics.

Below: Chief Justice Salmon P. Chase swore in fellow Ohioan Grant on March 20, 1869. In his inaugural address, Grant wanted Civil War bonds redeemed in gold. With a sizable number of African Americans in the crowd, he supported their right to vote with the ratification of the Fifteen Amendment. With proper treatment, Native Americans should be civilized and someday granted citizenship. Many of his appointments to executive offices were former Union generals. Grant's most surprising selection was James A. Longstreet as surveyor of customs for the port of New Orleans.

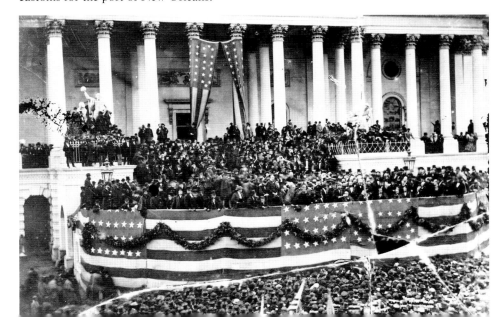

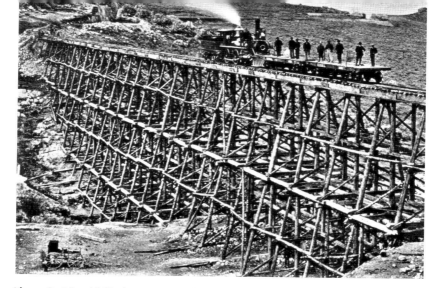

Above: In May 1869, the eastern and western tracks of the transcontinental railroad met at Promontory Point, Utah. A year earlier in the picture, workers finished building a trestle over the Salt Lake Valley. Congress chartered the Union Pacific Railroad in 1862, and shareholders created Crédit Mobilier, a construction company that overcharged the federal government. Members of Congress had the option of buying stock well below the market price then selling for a huge profit. Among more than thirty members of both parties, Rep. James A. Garfield of Ohio took advantage of the offer, which was unethical but not illegal at the time. The public did not hear of the scandal until the 1872 presidential election.

Below: Pres. Grant relaxed with Julia and son Jessie at the family cottage by the sea in Long Branch, New Jersey. In 1870, he signed legislation creating the Justice Department to enforced Reconstruction policies including the Ku Klux Klan Act, which allowed the president to declare martial law and suspend the writ of *habeas corpus* in parts of the South. Grant had already appointed William T. Sherman as general-in-chief to oversee the use of federal troops. The Panic of 1873 and depression would result in the North becoming more concerned about the economy rather than Reconstruction.

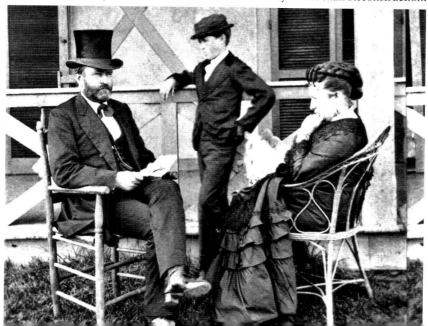

Left: With the completion of the transcontinental railroad, Utah Territory was less isolated, but statehood did not occur until 1896 because of the Mormon's polygamy. In November 1871, *Frank Leslie's Illustrated Newspaper* published this political cartoon, "The Mormon problem." Brigham Young wanted to know what to do about his wives and children. Pres. Grant told him to follow his example and give them offices.

Below: On March 23, 1872, Pres. Grant welcomed the Iwakura Mission sent by Emperor Meiji of Japan to "our good brother and faithful friend." The Emperor wanted to create a modern nation by observing Western technology and institutions. At the same time, Japan desired to renegotiate more favorable trade treaties and not fall victim to Western imperialism. After his presidency, Grant went on a world tour and spent three months as the guest of Emperor Meiji in the Summer Palace.

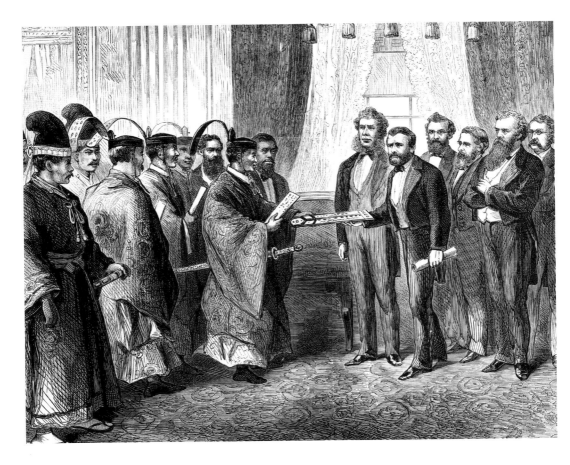

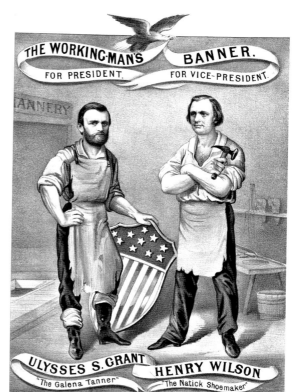

Republicans in the presidential election of 1872 appealed to tradesmen with their candidate's humble origins. A Radical, Henry Wilson of Massachusetts helped to form the Republican Party and supported workers' rights for whites and African Americans. Wilson's involvement in the Crédit Mobilier scandal did some damage to his image of personal integrity.

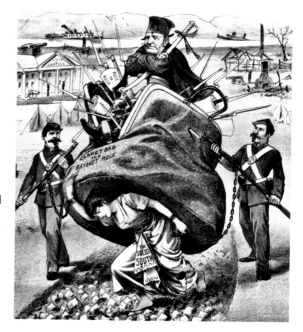

Puck magazine satirized the Democrat's viewpoint of Reconstruction. With sword in hand, Pres. Grant stands in a huge carpet bag symbolizing Republicans who went into the South seeking economic and political gain. Republicans feared a solid South of Democrats would become a reality without the protection of the U.S. Army to insure the voting rights of the former slaves.

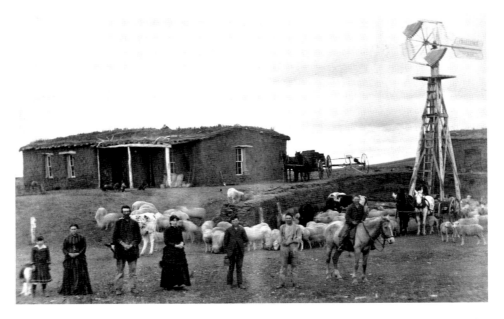

Above: The Republicans had passed the Homestead Act in 1862, helping the party to win the support of agrarians. Any loyal citizen at least twenty-one years old could apply for 160 acres of free land in the West. The recipient had to improve and live on the land for five years to gain title. Farming on the semi-arid Great Plains often proved to be difficult. On a mostly treeless landscape, homesteaders built sod houses and used buffalo dung for fuel. Windmills pumped the underground water from deep below the prairie. William Moore and his family lived in Nebraska.

Below: African Americans in the forty-first and forty-second Congress pose in this drawing. First row seated left to right: Sen. H. R. Revel, Mississippi; Rep. Benjamin S. Turner, Alabama; Rep. Josiah T. Walls, Florida; Rep. Joseph H. Rainy, South Carolina; and Rep. R. Brown Elliott, South Carolina. Second row: Rep. Robert C. De Large, South Carolina; and Rep. Jefferson H. Long, Georgia.

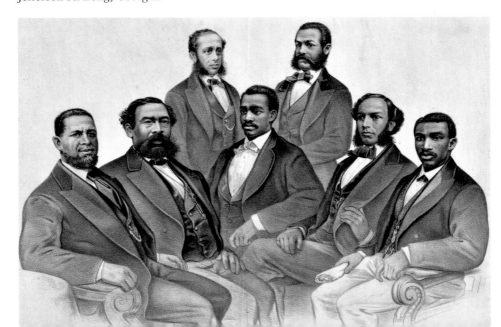

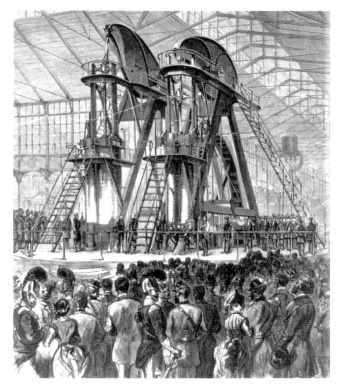

The Centennial Exposition opened in Philadelphia on May 10, 1876. Pres. Grant and Emperor Pedro II of Brazil observed the Corliss steam engine in Machinery Hall. Consumer products on public exhibition for the first time included a Wallace-Farmer electric dynamo, Alexander Graham Bell's telephone, a Remington typewriter, Hires Root Beer, and Heinz ketchup. A gift from France, the right arm and torch of the Statue of Liberty on display seemed to be symbolic of an unfinished nation ignoring African Americans and Native Americans among the exhibits.

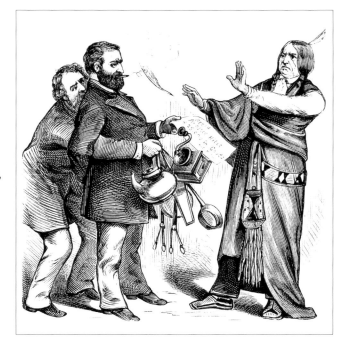

A year earlier in Washington, Pres. Grant and Interior Sec. Columbus Delano met with Chief Red Cloud of the Oglala Sioux. They were negotiating a treaty to have the government pay $25,000 in goods for the Black Hills in Dakota Territory. With rumors of a gold discovery, prospectors would soon be flocking into the region. Red Cloud refused the offer and took the unsigned treaty back to his tribal councils, who later agreed to accept it. Sitting Bull, Crazy Horse, and other Sioux chiefs defied Red Cloud, setting the stage for war. Delano soon resigned because of corruption in the Interior Department.

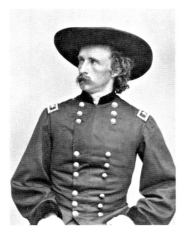

George Armstrong Custer was the youngest general in the Union Army and present in the McLean house when Gen. Grant accepted Gen. Lee's surrender. On June 25, 1876, Custer's 7th Cavalry Regiment of about 700 men suffered a major defeat near the Little Bighorn River in Montana. Casualties included 258 killed, among them Custer, and fifty-two wounded. Grant's government had ordered all tribes in the northern plains on to reservations or be considered belligerent. Custer's mission to enforce the degree resulted in a defeat against an overwhelming Sioux alliance of 2,500 warriors. At Wounded Knee in 1890, the 7th Cavalry sought revenge by massacring old men, women, and children who had strayed off the reservation in South Dakota.

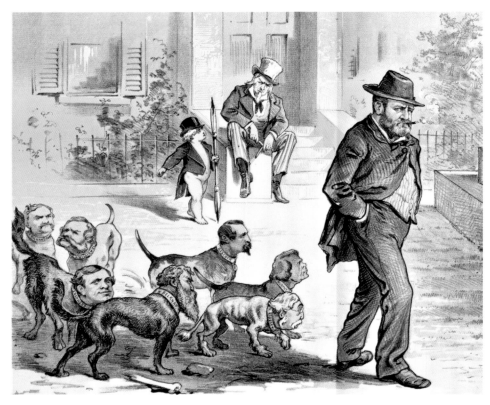

Puck and Uncle Sam watch in dismay at the former president being followed by unfaithful dogs named Richardson, Williams, Shepherd, Belkhap, Babcock, Murphy, and Robeson. Out of office for four years, Grant had thoughts in 1880 about running for a third term in the White House. Although honest himself, Grant had appointed a number of friends and associates to positions in his government, who had to later resign because of corruption. The scandals may have prevented him from winning the nomination.

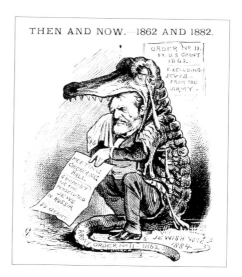

In December 1862, Gen. Grant had issued General Order Number Eleven because of the illegal selling of Southern cotton. He expelled Jewish traders and their families from the military districts of Kentucky, Tennessee, and Mississippi. Pres. Lincoln revoked the order the following month. Bernhard Gillam's 1882 cartoon published in *Puck* mistakenly showed the order excluding Jews from the Union Army. Pres. Grant appointed more Jews to office than his predecessors and won a majority of their votes in elections.

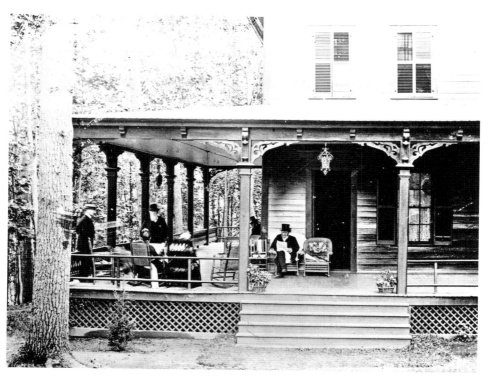

In 1884, Grant lost his savings from speculating on Wall Street. W. H. Vanderbilt loaned him money, which Grant also squandered on poor investments. In the picture, Grant is dying of throat cancer while writing his memoirs to pay his debts and provide an income for his wife. On the left, Julia Grant talked to Drs Douglas and Shrady. A few days after finishing the book, Grant died on July 23, 1885 in Mount McGregor, New York. *Personal Memoirs of Ulysses S. Grant* was a critical and financial success. Mark Twain called the book a literary masterpiece.

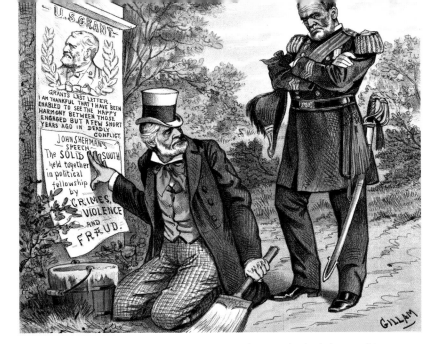

Above: In *Puck* on September 9, 1885, Gen. Sherman looked down with outrage at his brother Sen. John Sherman of Ohio for criticizing Grant's policies towards the South. The Senator had been a moderate about Reconstruction, wanting to see an early end of military governments in the South. At the Republican National Convention in 1880, he failed to win the nomination for president, among other reasons, because Grant's delegates refused to change their votes. On the thirty-sixth ballot, Sen. James A. Garfield of Ohio became the nominee.

Below: Grant's Tomb neared completion in 1896 on a site in Upper Manhattan overlooking the Hudson River. Funded by over $625,000 in donations, the mausoleum took six years to build. Architect John H. Duncan wanted to honor the greatness of the general and president, borrowing features from the tombs of Napoleon and Roman Emperor Hadrian. On the day of Grant's birth seventy-five years earlier, Pres. William McKinley took part in the dedication along with other dignitaries.

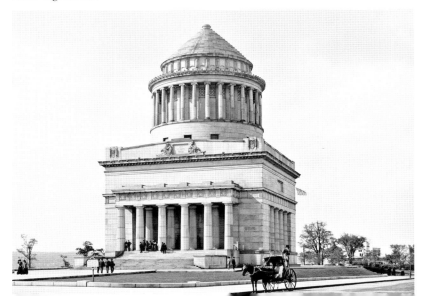

3

Rutherford Birchard Hayes

Rutherford Birchard Hayes, the nineteenth president, held office from March 1877 to March 1881. The American Political Science Association in 2018 gave him a rating of 41.5 percent, placing him at twenty-ninth of the forty-three presidents and fourth among those from Ohio.

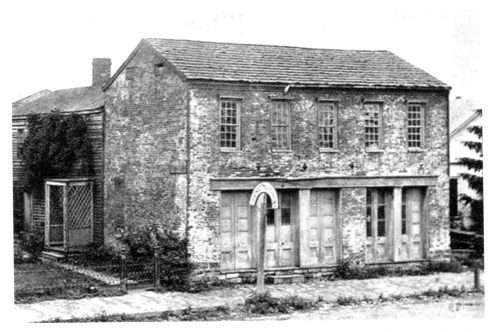

On October 4, 1822, Rutherford Birchard Hayes was born in this house in Delaware, Ohio. Ten weeks earlier, his father died and Sophia Hayes never remarried. Her brother, Sardis Birchard, resided for a while with the family, becoming more like a father than an uncle to Rutherford. Birchard would later help to finance his nephew's education. After attending a public school in Delaware, he went to private schools in Norwalk, Ohio and Middletown, Connecticut.

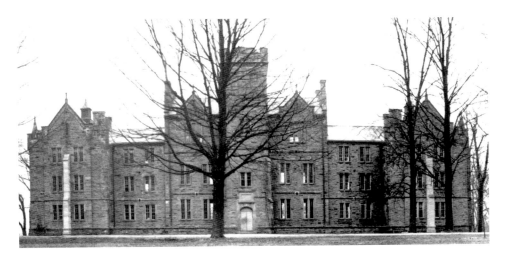

Hayes graduated with honors in 1842 from Kenyon College located in Gambier, Ohio. Giving the valedictorian address, he spoke about his involvement in student societies and thanked the teachers for his quality education. Alumni of the college included Edwin M. Stanton who would serve as Lincoln's Secretary of War and two justices of the U.S. Supreme Court: David Davis and Stanley Matthews. Politics on the campus intrigued Hayes and he joined the Whig Party.

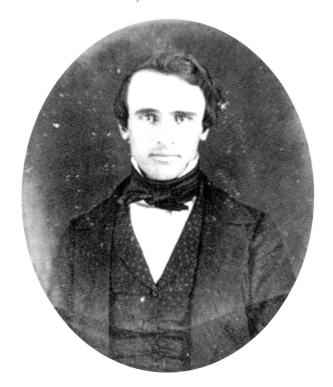

While reading law in Columbus, Ohio, Hayes decided to enroll at Harvard University. He graduated and then passed the Ohio Bar exam in 1845. He practiced law in Upper Sandusky (Fremont), Ohio but moved to Cincinnati in 1850, seeking more clients. The young attorney liked the city where his business improved, and he joined the Odd Fellows Club and the Cincinnati Literary Society.

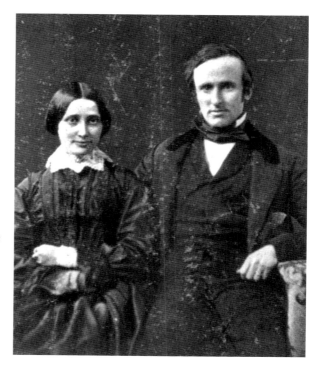

Nine years her senior, Rutherford and Lucy Hayes posed after their marriage in Cincinnati on December 30, 1852. Two years earlier, they were in a wedding party, and he began to feel an attraction towards her. A graduate of the Cincinnati Wesleyan Female College, Lucy impressed him with her intellect and advocacies. She favored women's suffrage and the abolition of slavery. She was also an accomplished pianist.

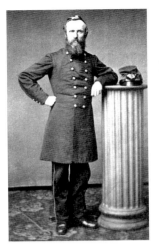

Hayes had been at first opposed to war against the South to save the Union but changed his mind after the Confederate attack on Fort Sumter. He joined the 23rd Ohio Regiment as a major and first saw action in western Virginia. In September 1862, the regiment fought at South Mountain in Maryland where he led a charge and suffered a bullet wound that fractured the bone of his left arm. After promotion to colonel, Hayes became a brevetted brigadier general and skirmished in July 1863 against Gen. John Hunt Morgan's cavalry in southeastern Ohio. His brigade joined the Army of the Shenandoah in the Valley Campaign of 1864 in Virginia. He mustered out of the army in July 1865 as a brigadier general. In his memories, Grant praised Hayes for his gallantry.

The Ohio Statehouse had been rebuilt by the start of the Civil War. In December 1865, Hayes represented Cincinnati's district in Congress. He considered himself a moderate Republican but voted with the Radicals on Reconstruction. He proposed legislation for civil service reform without success. After reelection, he resigned in 1867 and ran for governor of Ohio. Supporting the ratification of the Fifteenth Amendment, Hayes opposed Allen G. Thurman, who did not want to guarantee suffrage for African American males. Hayes barely won the governorship, but the Democrats gained control of the state legislature and refused to ratify the amendment. His reelection came with a Republican takeover in the legislature, which ratified the amendment. Hayes's biggest accomplishment was the creation of the Agricultural and Mechanical College, later renamed The Ohio State University.

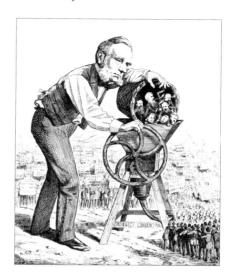

A political cartoon published a month before the 1876 Republican convention satirized Republican National Chairman Edwin D. Morgan. He is putting the leading candidates into a meat grinder labeled Cincinnati Convention: James G. Blaine, Rutherford B. Hayes, Oliver P. Morton, Roscoe Conkling, Benjamin H. Bristow, and Elihu Washburne. Morgan wondered who would be the winner. Ohio's first three-term governor, Hayes became an attractive candidate for many Republicans.

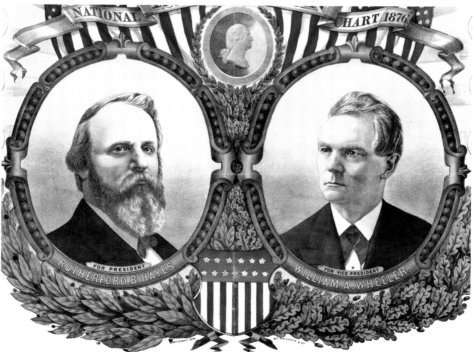

The senator from Maine, Blaine started with the lead at the convention but could not muster a majority of delegates. With the help of Sen. John Sherman of Ohio, Hayes won the nomination on the seventh ballot. He never heard of Rep. William A. Wheeler of New York until he was chosen as his running mate. Being the ruling party, Republicans felt vulnerable due to the awful state of the economy and mostly campaigned against the Democrats for causing the Civil War. James A. Tilden, governor of New York, wanted civil service reform like his opponent, and focused on the depression and the corrupt administration of Pres. Grant.

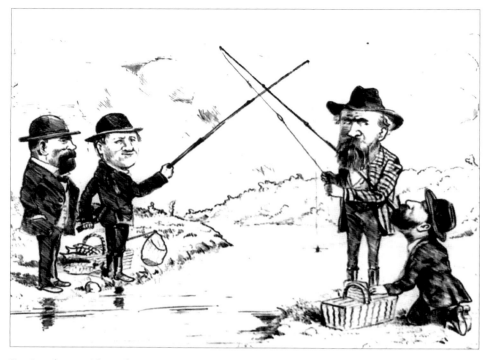

During the presidential campaigns, a cartoonist envisioned the candidates on a fishing trip. On the left, Gov. Tilden has a basket full of fish. Across the stream, Gov. Hayes has not caught any fish. Pres, Grant on his knees told him to forget the reform worm and use an anti-Catholic worm. While governor, Hayes supported Protestants in Ohio who opposed state funding for Catholic schools.

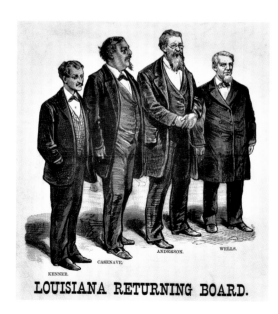

In the 1876 presidential election, Tilden received approximately 250,000 more popular votes than Hayes. However, neither candidate had a majority in the Electoral College because of the disputed votes in four states. Congress created a commission dominated by Republicans, which gave all the votes to Hayes. On March 2, 1877, Congress met in a joint session and declared Hayes and Wheeler to be president and vice president by one electoral vote. Frustrated Democrats printed a handout entitled "The Political Farce of 1876." In one of the disputed states, Republicans on the Louisiana Returning Board inevitably supported their party's choice for president.

Above: Outraged by the decision of the Electoral Commission, Rep. Henry Watterson of Kentucky threatened to lead an army of 100,000 men to Washington if Tilden was denied the presidency. Pres. Grant reacted by increasing military security around the capital. Before Congress confirmed the election of Hayes, Republicans promised concessions to the Democrats to prevent a filibuster. The Compromise of 1877 included: withdrawal of the U.S. Army from all the former Confederate states, appointment of a Southern Democrat to the cabinet, and the right to deal exclusively with African Americans in the South. Many historians have questioned the significance of the compromise since the North was losing interest in Reconstruction.

Below: Eight years later, *Puck* magazine published a cartoon flaunting a happy Tilden in retirement. He sat in a rocking chair, raising a glass of the elixir of youth over his head and holding a telephone receiver to his ear. Next to the telephone on the wall, a sign proclaims the inauguration of Grover Cleveland. Tilden offered a toast to the first Democratic president since before the Civil War.

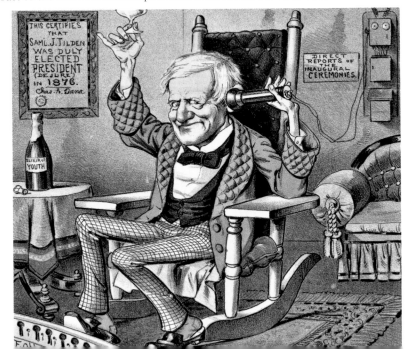

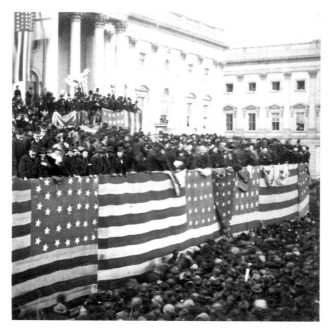

As March 4, 1877 fell on a Sunday, Pres. Hayes took the oath of office in the White House on Saturday. He gave his inaugural address in front of the Capitol on Monday, attempting first to calm the fervor over the decision of the Electoral Commission, but many Democrats would not be consoled and called him "His Fraudulency." He promised home rule in the South, reform of the civil service system, and a complete return to the gold standard.

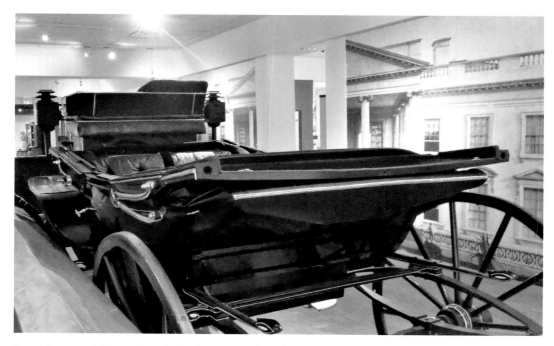

Pres. Hayes used this carriage during his years in the White House. It is now in the Hayes Museum and Presidential Library at Fremont, Ohio. He loaned it to Pres. Garfield during his time in Washington since his fellow Ohioan could not afford anything so grand. In the fall of 1881, Hayes brought the carriage to Spiegel Grove, where the family used it for a number of years. (*Author's Collection*)

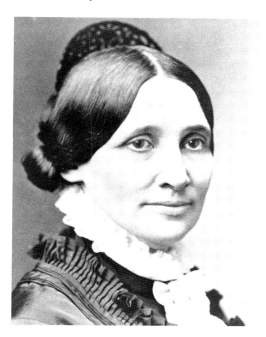

Lucy Hayes was the first wife of a president to have a college degree. First Ladies were becoming more familiar to the public because of the increasing number of female journalists. They portrayed her as attractive, lovable, and the life of every party. Lucy's empathy and genuineness made her popular in Washington. Years later, historians called her "Lemonade Lucy" because she supported the temperance movement, but the President gave the order to outlaw alcohol in the White House. She was the first to use a telephone, typewriter, and phonograph in the White House besides suggesting the installation of toilets with running water.

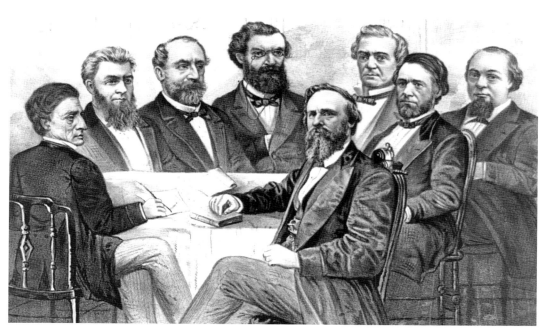

Pres. Hayes sat in the White House with his cabinet. From left to right: Sec. of State William M. Evarts; Postmaster Gen. David M. Key; Attorney Gen. Charles Deven; Interior Sec. Carl Schurz; Navy Sec. Richard W. Thompson; Treasury Sec. John Sherman; and War Sec. William McCrary. Trying to unify the Republican Party around his administration, he selected members from New York, Tennessee, Massachusetts, Missouri, Indiana, Ohio, and Iowa.

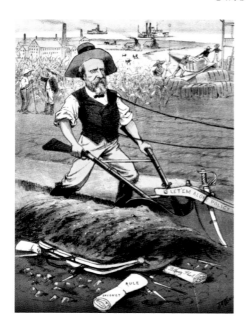

Supporting Southern home rule, Hayes wanted to preserve the civil rights of African Americans and sustain the votes of Republicans in the South. Both goals were mere hopes with his reassignment of the army, symbolized by rifles made into plow handles. In the background, former slaves appeared to be in a new form of involuntary servitude, punishment for violating vagrancy laws.

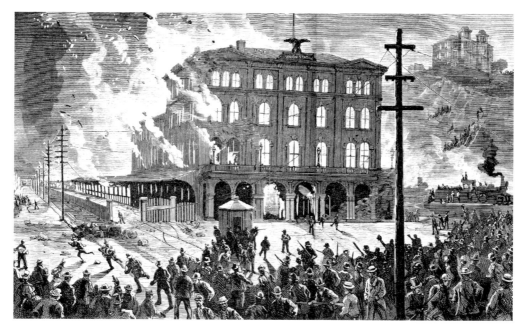

The Great Railroad Strike of 1877 began with workers protesting wage cuts resulting from the Panic of 1873 and the ensuing depression. Strikes occurred in Baltimore, Chicago, St. Louis, and other cities with sporadic rioting. After the breakout of violence in Pittsburgh, Pres. Hayes sent troops under Gen. Winfield Scott Hancock to protect government property, which was the first use of federal forces to break a strike against a private business. During a riot, the Union Depot in Pittsburgh burned to the ground on July 22, 1877.

Pres. Hayes tried unsuccessfully to have Congress reform the civil service system. Issuing an executive order, he banned the practice of requiring federal workers to contribute money for the campaigns of politicians. Chester A. Arthur, Collector of the Port of New York, and his subordinates ignored the president's order. Hayes then called for their resignations, which they again ignored knowing Rep. Roscoe Conkling of New York would support them. Hayes finally fired Arthur during a recess of Congress. Ironically while serving as president, Arthur signed the Pendleton Act, the first significant reform of the spoils system.

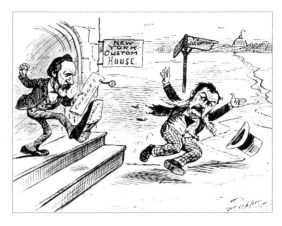

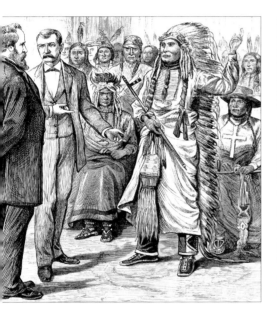

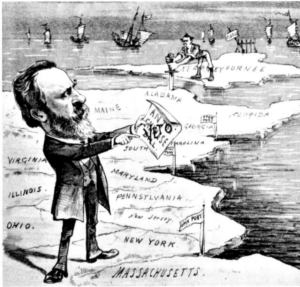

Above left: In the East Room of the White House on September 28, 1877, Pres. Hayes and Sec. Evarts met with Sioux Chiefs Spotted Tail and Red Cloud. They came to Washington wanting the president to enforce the treaties of 1868 and 1869. Hayes prevented the War Department from taking over the Bureau of Indian Affairs and supported a long-range policy of education for assimilating and making them citizens. Mark Twain later said that the U.S. government planned to "educate them to death."

Above right: The Burlington Treaty of 1868 allowed unrestricted immigration from China. After the Panic of 1873, unemployment increased dramatically. Anti-Chinese riots broke out in San Francisco, and critics of the treaty organized the Workingman's Party, blaming it for lower wages and greater joblessness. Congress passed legislation in 1879, which annulled the treaty. Hayes vetoed the bill because changing a treaty had to be negotiated with the other country. Outraged Democrats in the House wanted to impeach him. Declining to pursue reelection, Hayes left office a year before Congress passed the Chinese Exclusion Act.

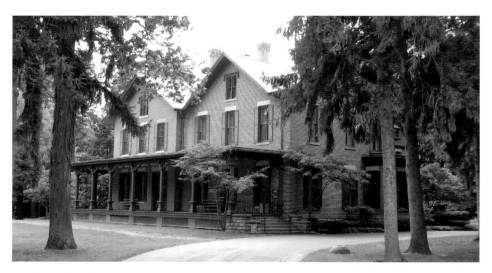

Sardis Birchard, Hayes's uncle, finished building his mansion as a summer home during the Civil War. Hayes inherited Spiegel Grove and moved his family into the house in 1874, where they lived until his years as governor and president. Leaving Washington in 1881, he returned home and enlarged the house to include a library for his 12,000 books and a reception room for visiting dignitaries. Decedents lived in the house until 1965 when the state of Ohio assumed ownership. (*Author's Collection*)

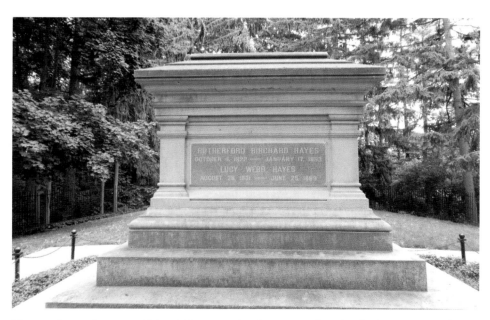

The granite tombstone at Spiegel Grove marks the graves of Rutherford B. Hayes and Lucy Webb Hayes. In the rear, Webb C. Hayes and his wife are buried. He won the Medal of Honor in the Philippine Insurrection after the Spanish American War. His commitment brought about the creation of the Hayes Museum and Library. (*Author's Collection*)

4

James Abram Garfield

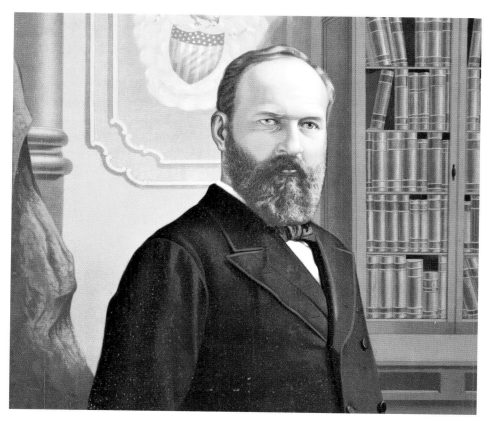

James Abram Garfield, the twentieth president, held office from March 1881 to September 1881. The American Political Science Association in 2018 gave him a rating of 36 percent, placing him at thirty-third of the forty-three presidents and sixth among those from Ohio.

Above: James A. Garfield was born on November 19, 1831 in Orange Township, Ohio. A replica of the Garfield cabin stands near the site in the present community of Moreland Hills. Eliza Garfield raised him after the death of her husband Abram in 1833. The Garfields attended a Disciples of Christ church in the township. Growing up in poverty, the young Garfield enjoyed his mother's stories about their Welsh ancestors and the one who had been a knight at Caeffili Castle in Wales. Schoolmates made fun of him for being poor, which may have caused sensitivity to affronts in later life. When not doing farm work, he loved to read, escaping the insecure world around him. (*Author's Collection*)

Below: The picture shows an abandoned canal lock south of Cleveland in a region now under the jurisdiction of the National Park Service. After reading tales about sailing on the high seas, Garfield left home at sixteen years of age and set out for the busy docks of Cleveland, hoping to find adventure and a job on a lake vessel. Instead, he could only find work as a driver of mules, pulling boats on the Ohio and Erie Canal. After only six weeks, he returned home, sick with malaria from mosquitoes in the mucky water in the canal. His health returned after a long convalescence, and his mother convinced him to attend school rather than returning to work on the canal. He enrolled in 1848 at Geauga Academy in Chesterland Township. He was an excellent student with a particular interest in languages and elocution. While attending the academy, he met his future wife, Lucretia Rudolph. In March 1850, Garfield experienced a religious reawakening and members of the Disciples of Christ Church baptized him in the cold waters of the Chagrin River.

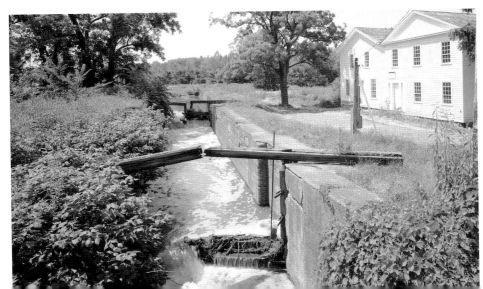

Garfield studied and taught from 1851 to 1854 at Hiram College, then named the Western Reserve Eclectic Institute. He supplemented his income by preaching on Sundays in the region including a community church in Mecca, Ohio. The college moved the church in 2008 to Hiram for the location of the Garfield Institute for Public Leadership. Lucretia Rudolph also attended the college, studying to be a teacher. Wanting to further his education, Garfield attended Williams College in Massachusetts, where he first experienced the social and political world outside of Hiram. (*Author's Collection*)

Garfield's statue stands next to Koritansky Hall. After graduating from Williams College with honors in 1856, he returned to Hiram as a professor of ancient languages and then became president the following year. However, he started to believe his future was in politics and not education and joined the Republican Party in 1857. A year later, he married Lucretia at the home of her parents in Hiram and won election to the Ohio Senate. In the meantime, he became an attorney after reading the law by himself. (*Author's Collection*)

With the outbreak of the Civil War, the Ohio governor commissioned Garfield a colonel, and he recruited the 42nd Ohio Volunteer Infantry. His regiment helped in driving Confederate forces out of eastern Kentucky in January 1862. Promoted to major-general, he now had command of the 20th Brigade in the Army of the Ohio. His unit fought on the second day at Shiloh and helped win the battle. In the summer, he went home to recover from jaundice and Lucretia nursed him back to health. Local Republicans nominated him for the House of Representatives, but he refused to campaign for the seat. Gen. William S. Rosecrans appointed him to Chief of Staff for the Army of the Cumberland, but Rosecrans's incompetence led to defeat at the Battle of Chickamauga in September 1863. War Sec. Stanton ordered Garfield to Washington, where he promoted him to major-general for helping to save the army from a disaster at Chickamauga. Garfield felt slighted when Gen. Grant replaced Rosecrans with Gen. George C. Thomas. Fellow Ohioan, Treasury Sec. Salmon P. Chase helped convince Garfield to resign from the army and assume his seat in Congress to help the Radical Republican agenda.

Besides having seven children, Lucretia Garfield turned out to be an astute adviser to her husband's political career. After graduating in 1855 from the Western Reserve Eclectic Institute, she taught algebra, Latin, and French then moved on to schools in Ravenna and Cleveland. After marriage, they lived in Hiram, but James was often away from home. She criticized him for his lack of passion towards her. Perhaps, he had married her out of an obligation since they had been romantically involved for a number of years. Garfield later admitted to her about having an extramarital affair in 1863 with Lucia Calhoun. A reporter in Washington for *The New York Times*, Calhoun wrote an essay explaining her beliefs about female equality. To save their marriage, Garfield promised Lucretia that he would never again be unfaithful to her. The death of their young child brought them closer together as a loving couple.

Rep. Garfield served his congressional district from 1863 to 1880. Taking time out from his legislative duties in 1866, he helped win a case for the defendant before the Supreme Court in *ex parte Milligan*. In spite of favoring Radical Reconstruction, he supported the southern sympathizer living in Indiana, who went to prison after a military trial while the civil courts were operating during the war. Although a firm believer in the Gold Standard, Garfield lost his seat in 1867 on the Ways and Means Committee because he wanted lower tariffs in opposition to Republican policies. Three years later, he chaired the House Banking Committee and investigated the Black Friday Gold Panic.

On May 30, 1868, the first national observance of Decoration Day (Memorial Day) took place at Arlington National Cemetery. Rep. Garfield spoke in front of the mansion, formerly the home of Gen. Robert E. Lee. Presidential candidate Gen. Grant attended the solemn event. Garfield said his words failed to express the nation's gratitude for the sacrifice of the 15,000 men buried in the cemetery.

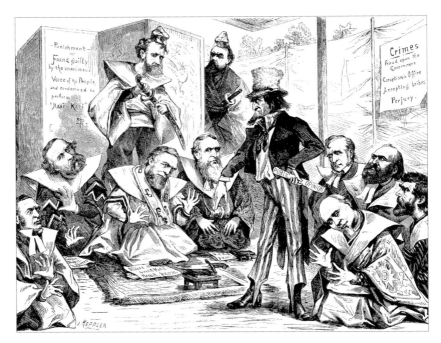

Frank Leslie's Illustrated Newspaper published a cartoon in 1873 satirizing the Crédit Mobilier scandal, which became public knowledge a year earlier. Representing public opinion, Uncle Sam demanded that Rep. Smiler commit *harakiri* because of his perjury and greed. On the right in the middle of the last row, Rep. Garfield sat among members of Congress, mostly Republicans, implicated in the scandal. Garfield unethically made $329 in the stock deal but still won reelection to the House of Representatives.

Before the embarrassment of the Crédit Mobilier scandal, Garfield relaxed with his daughter Mollie. He opposed Pres. Grant's reelection until the newspaper editor Horace Greeley, his political enemy, ran for president as a Liberal Republican and a Democrat. He went to the Republican National Convention in 1876 supporting Sen. James G. Blaine for president but after six ballots switched to Gov. Rutherford B. Hayes. With thoughts of spending all of his time practicing law, he instead ran again and won in a one-sided election. Republicans had urged him to stay in Congress. In January 1880, Ohio's General Assembly elected him to the U.S. Senate with the term beginning in March of the following year.

Above: Garfield went to the 1880 Republican National Convention in Chicago as head of the delegation supporting Sen. John Sherman of Ohio. He gave a rousing nominating speech, and Sherman may have wondered about his motives. Sen. Roscoe Conkling of New York led the Stalwarts, who wanted a third term for Grant. Sen. Blaine was also a major contender for the nomination. After thirty-five ballots, the convention remained deadlocked in need of a compromise candidate. Seeing Grant as unacceptable, the Blaine and Sherman delegates decided to vote for Garfield on the next ballot, and he became the "dark horse" nominee for president. Mostly to appease Conkling, the Republicans agreed to make Chester A. Arthur the running mate of Garfield.

Below: Grant gave his sword to Garfield as a gesture in *The Appomattox of the Third Termers—Unconditional Surrender*. John Sherman and James G. Blaine take down the third term flag. On the far left, Carl Schurz stands behind Puck watching the ceremony. A Fort Alliance cannon points down at Grant's forces on the right, appearing as ghosts of Civil War memories. On the tombstone, "Chicago June 8, 1880" recorded the date of Grant's demise from politics.

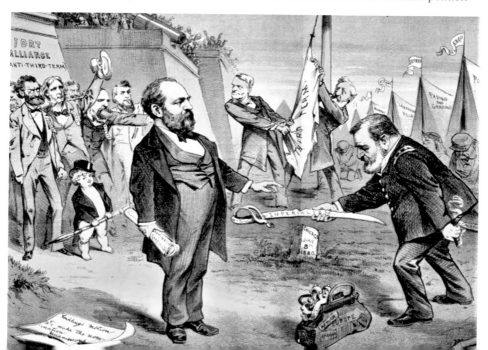

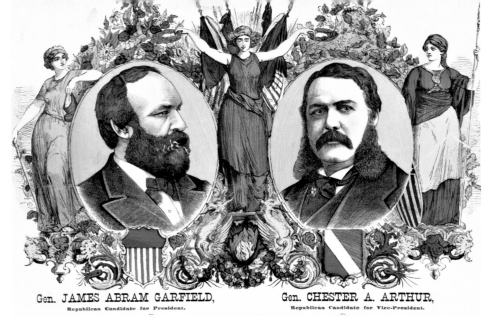

Gen. JAMES ABRAM GARFIELD,
Republican Candidate for President.

Gen. CHESTER A. ARTHUR,
Republican Candidate for Vice-President.

Above: A campaign poster identified both candidates as Union generals in the Civil War. The Democratic Party selected Gen. Winfield Scott Hancock, a career soldier from Pennsylvania who had successfully commanded federal troops in the Battle of Gettysburg. Nonetheless, Republicans continued at first to "Wave the Bloody Shirt" blaming Democrats for causing the war. This tactic began to be less effective among the voters, and the campaign switched to supporting a high protective tariff as opposed to Democrats wanting a lower tariff for revenue only.

Below: Today a National Historic Site in Mentor, Ohio, Garfield bought this house including a farm in 1876. Reporters covering the 1880 election gave it the name of Lawnfield. After the convention, the nominee went to New York, where he met with the Stalwarts to unite the party behind him. Garfield then returned to Mentor and campaigned from the front porch of his home. Tracks of the Lake Shore and Michigan Southern Railroad ran across his farm, transporting visitors to hear him speak. He also communicated by telegraph to the world outside of Mentor. The 1880 election turned out to be very close with Garfield winning by only 1,898 popular votes, the smallest margin in history, but he won 214 electoral votes to 155 for Hancock. The Democratic candidate swept the South.

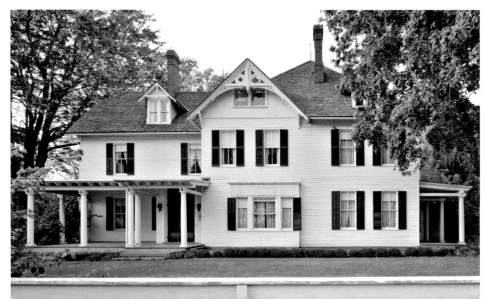

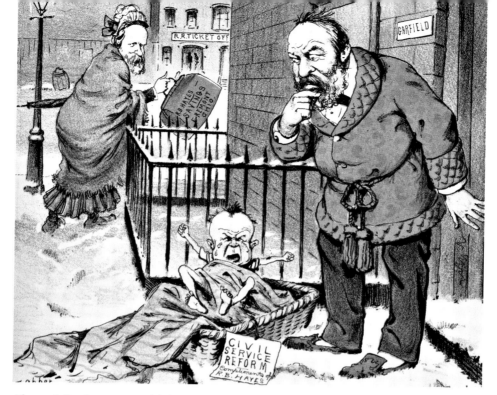

Above: A *Puck* cartoon published on January 16, 1881 showed Pres. Hayes disguised as a woman heading for retirement in Fremont, Ohio. He left a crying baby labeled "Civil Service Reform, compliments of R. B. Hayes" on the doorstep of the president-elect. He had failed to curtail the spoils system's blot on the national government. Garfield appeared puzzled as to his course of action.

Below: Pres. Garfield's speech at his inauguration in March 1881 was disappointing to many in the crowd. After upholding the gold standard, he called for supporting the civil rights of African Americans besides the importance of education for all Americans. At the expense of preparing for his speech, Garfield had been spending most of his time trying to make appointments to please the different factions of the party. With a limited knowledge in foreign affairs, he depended on Sec. of State Blaine to advise him on policies involving Latin America and the Far East.

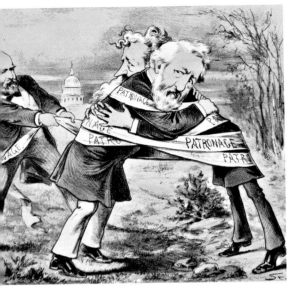

During the month of his inauguration, *Puck* satirized Garfield as the new president frustrated with the patronage demands of Conkling and Blaine. Garfield favored some kind of reform to curb the abuses of patronage but disappointed advocates with his inadequate suggestions. At the same time, he appointed friends and political cronies to government jobs. The spoils system especially hurt the Post Office Department with rampant corruption at all levels. He insisted the profiteers should resign and be prosecuted.

Charles J. Guiteau expected to be the American Consul in Paris, fantasizing his campaigning for Garfield had helped him win the election. Guiteau did not qualify for the position nor could he speak French. With his autographed picture as a calling card, he talked to Garfield and Blaine without success and began to believe they turned him down because he was a Stalwart. Supposedly, he bought a revolver with an ivory handle because it would look better in a museum. On July 2, 1881 in Washington's Baltimore and Potomac Railroad Station, Guiteau's first shot grazed Garfield's arm, but the second one penetrated his back, fracturing a rib, and lodging itself in the abdomen. Garfield died from infection in September. Guiteau pleaded not guilty because of insanity at the start of his murder trial in November. As his bizarre behavior intensified, he appeared to be unfazed by the reality of a scaffold awaiting him. He made plans for a lecture tour expecting Pres. Arthur to pardon him. On the day of his execution in June 1882, Guiteau danced to the gallows and smiled at the reporters and spectators.

On Decoration Day in 1890, Pres. Benjamin Harrison and Rutherford B. Hayes attended the dedication ceremony for the Garfield Monument at Lake View Cemetery in Cleveland. The crypt today contains the caskets of James A. Garfield and Lucretia Garfield besides the ashes in urns of daughter Mary (Mollie Garfield) Stanley-Brown and her husband, Joseph Stanley-Brown, the President's White House secretary.

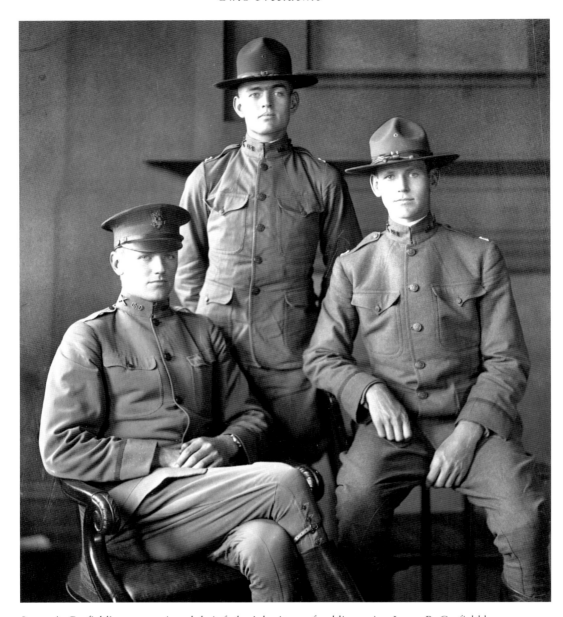

James A. Garfield's sons continued their father's heritage of public service. James R. Garfield became Pres. Theodore Roosevelt's Interior Secretary, and Harry A. Garfield, president of Williams College and then head of the Federal Fuel Administration under Pres. Wilson. Garfield's grandsons served in the Army during World War I. Left to right: Capt. John Garfield fought with the 134th Field Artillery in the Meuse-Argonne. Maj. Newell Garfield saw action in the same campaign with the 322nd Field Artillery. Maj. James Garfield spent the war teaching in the field artillery school at Fort Sill, Oklahoma. (*Cleveland Public Library*)

5

Benjamin Harrison

Benjamin Harrison, the twenty-third president, held office from March 1889 to March 1893. The American Political Science Association in 2018 gave him a rating of 37.6 percent, placing him at thirty-first of the forty-three presidents and fifth among the eight from Ohio.

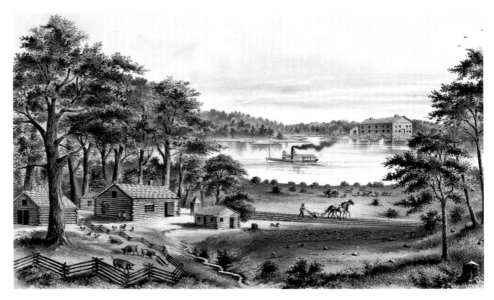

Benjamin Harrison was born on August 20, 1833 at North Bend, Ohio. The idyllic picture of the Harrison farm with log cabins on the Ohio River later portrayed him like his grandfather as a common man of the people. Seven years old at the time, he did not attend the inauguration of Pres. William Henry Harrison. His father, John Scott Harrison, served two terms in the House of Representatives but abandoned politics to farm his land, providing a modest income for the family. What money he saved went to the education of his sons.

Harrison went to a local one-room schoolhouse until his father hired a tutor to educate him at home. Starting in 1847, he attended Farmer's College (shown in picture), an agricultural school, near Cincinnati and took science classes taught by John Witherspoon Scott, a Presbyterian minister and a Yale graduate. Rev. Scott had been at Miami University in Oxford, Ohio until he was fired because of his vocal opposition to slavery. Harrison met Scott's daughter, Caroline, and six years later, her father married them in Oxford.

In 1850, Harrison enrolled in Miami University and joined two fraternities, making lifelong friends including his vice-presidential running mate Whitelaw Reid. Professor of history and political economy, Rev. Hamilton Bishop proved to be an important influence on the young man. Bishop's friends included Rev. Scott, Henry Clay, and William Holmes McGuffey, author of school books. After graduating in 1852, Harrison studied law under Judge Bellamy Storer in Cincinnati and then passed the Ohio Bar two years later.

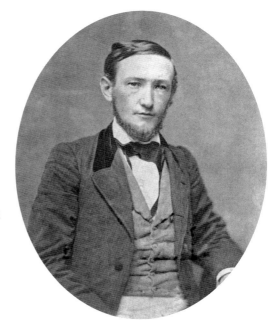

While living at North Bend, Harrison inherited land from his aunt, which he sold and then moved to Indianapolis, Indiana in 1854. He practiced law with John H. Ray and became a commissioner for the U.S. Court of Claims. After working with other lawyers, Harrison formed his own firm in 1860. Three years earlier, he successfully ran for attorney of Indianapolis. Originally a Whig, he joined the Republican Party and served as secretary for the party's state committee.

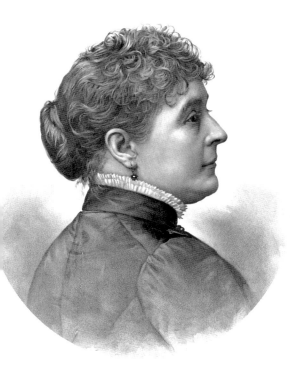

Caroline Harrison studied music, theatre, literature, and art at the Oxford Female Institute. After graduating in 1852, she taught in Carrollton, Kentucky until returning to Ohio because of pneumonia. Soon after the birth of Russell in 1854, their home in Indianapolis burned to the ground. She gave birth to Mary in 1858. Mrs. Harrison was an active member of the First Presbyterian Church, Indianapolis Orphan Asylum, and the Daughters of the American Revolution. An accomplished pianist, she also loved to paint.

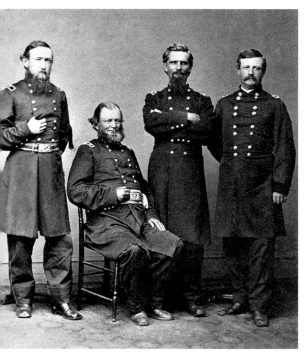

At the start of the Civil War, Gov. Oliver Morton asked Harrison to help organize a regiment in the northern region of the state. Morton commissioned him a colonel and the 70th Indiana Infantry Regiment mustered into the Union Army on August 7, 1862. The regiment spent two years in Kentucky and Tennessee mostly guarding railroads until assigned to Gen. Sherman's campaign against Atlanta. Harrison saw numerous actions from the Battle of Resaca to the Siege of Atlanta. His brigade then played a role in the victory at Nashville in December 1864. Promoted to brevet-brigade general of volunteers, he marched with his unit in the Grand Review of the Armies in Washington on May 24, 1865. Before going back to Indiana, he posed for this picture from left to right: Gen. Benjamin Harrison, Gen. Ward, Gen. Dustin, and Gen. Cogswell.

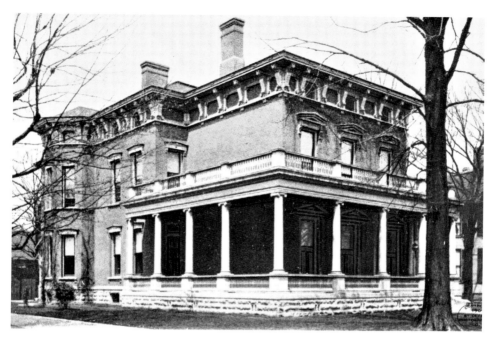

Harrison returned to his law practice in Indianapolis and gained a reputation as one of the best attorneys in the state. He unsuccessfully ran for governor in 1872 but continued to speak for the campaigns of Republicans. The Harrison family moved into a new house in 1874. Two years later, he again lost an election for Governor. Attending the 1880 Republican National Convention, he played a significant role with the Indiana delegation in breaking the deadlock and nominating Garfield for president. The state legislature elected him to the Senate, where he served until 1887. He supported pensions for veterans and in vain expenditures to improve the education of whites and African Americans in the South. (*New York Public Library*)

Sen. Blaine decided not to seek the presidential nomination at the Republican National Convention in 1888. Sen. John Sherman continued to lead the roll calls then fell behind and lost to Harrison on the eighth ballot. Levi P. Morton of New York became his running mate. During the election, Harrison capitalized on his grandfather's log cabin campaign in 1840. He ran against the incumbent president, Grover Cleveland. Democrats wanted to decrease the high tariffs, an unfair tax burden for most Americans. Republicans argued that a protective tariff resulted in higher wages and employment vital to the nation's economic growth. Harrison defeated Cleveland in the Electoral College but not in the popular vote.

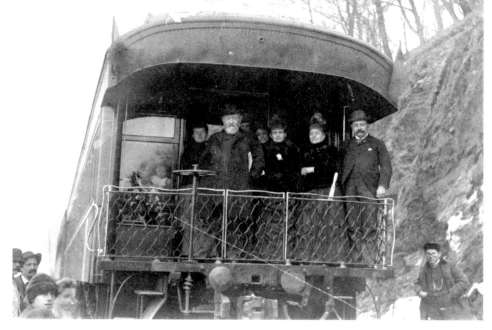

Above: In late winter 1889, crowds of well-wishers greeted Harrison at train stations on the way to Washington. Caroline stands on his left looking haggard. Tragically, she would not survive her husband's presidency, dying of tuberculosis in 1892. Four years later, he married Mary Dimmick, a widow twenty-five years younger than him. His children did not attend the wedding.

Below: Pres. Harrison's inaugural address in March 1889 turned out to be half the length given by his grandfather. As expected, he promised Union Army veteran pensions, civil service reform, a protective tariff, and a gold standard. Declaring an affirmation of the Monroe Doctrine, he favored the immediate construction of modern warships. In the Pension Building, John Philip Sousa's Marine Band entertained a large crowd at the inaugural ball.

Above: Looking weary, Rev. Scott now worked at the Pension Bureau, a position he owed to his son-in-law. He lived with the President and First Lady in the White House. A month after his daughter's death, he died at the age of ninety-two in Washington on November 29, 1892. Today, Scott's home during the 1840s survives in the Mt. Pleasant neighborhood of Cincinnati. A plaque marks it as a station on the Underground Railroad.

Below: The president sat with his cabinet in 1889, first row left to right: Pres. Harrison, Treasury Sec. William Windom, Postmaster Gen. John Wanamaker, War Sec. Redfield Proctor, and State Sec. James G. Blaine; second row: Attorney Gen. W. H. Miller, Interior Sec. John W. Noble, Agriculture Sec. Jeremiah Rush, and Navy Sec. Benjamin E. Tracey.

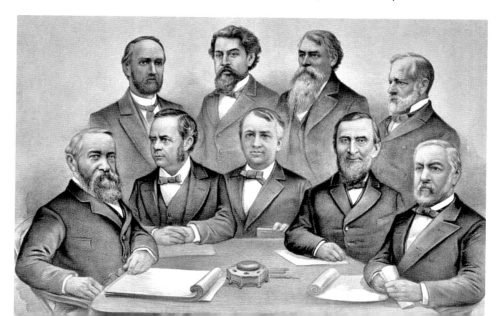

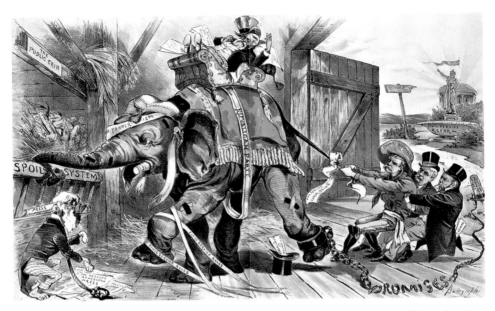

Above: In spite of the Pendleton Act, the spoils system continued to be a problem. Harrison appointed reformers like Theodore Roosevelt and Hugh Smith Thompson to the Civil Service Commission but feared dividing the Republican Party over the patronage controversy. In the end, his promises of pushing for reform went unfulfilled.

Below: Pres. Harrison went to Maine for a vacation in 1889 and crossed Frenchman's Bay on the steamboat *Sappho*, which transported the wealthy to Mount Desert Island. The Bar Harbor Band posed in front of the president and his guests from left to right: Sec. of State Blaine, Caroline and Benjamin Harrison, and Rep. Henry Cabot Lodge of Massachusetts.

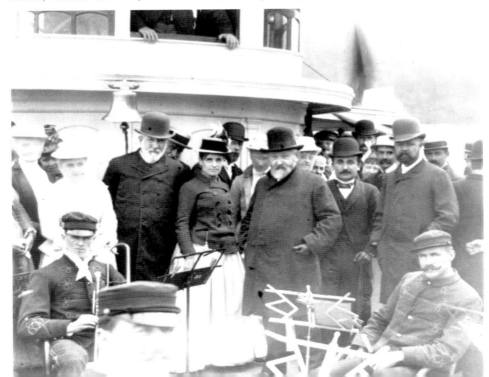

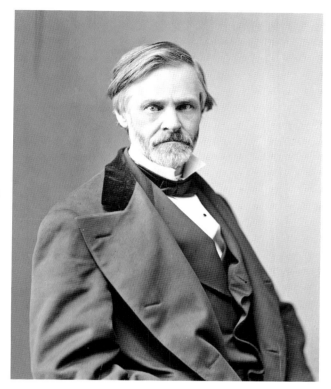

At the opening of the Fifty-first Congress, Sen. John Sherman introduced legislation, which would bear his name, the Sherman Antitrust Act. He commended corporations for the growth of the nation's economy but wrote into law that any combination in restraint of trade or commerce is illegal. Pres. Harrison signed the bill on July 2, 1890. Passed three years earlier, Pres. Cleveland had signed the Instate Commerce Act to regulate the rates charged by railroads. Both landmark laws would need amending to be more effective.

Responding to political pressure in 1890, Congress passed the Dependent Pension Act, which dramatically increased the number of pensioners. Serving a minimum of ninety days, disabled veterans not injured in the Civil War could now collect a pension. Some 1 million Union Army veterans were on the pension roll, accounting for 40 percent of the federal budget by 1893. Many African Americans in the South endured discrimination by not receiving benefits even though the Grand Army of the Republic, a fraternal association, campaigned for their equal treatment. Harrison had unsuccessfully asked Congress to pass legislation for protecting the civil rights of African Americans.

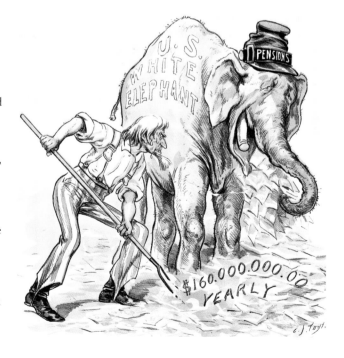

Capt. Alfred Thayer Mahan was lecturer and later president of the Naval War College. He wrote *The Influence of Sea Power on History, 1660–1783*. The book became an instant success and affected the strategic policies of the United States. He believed the nation needed a strong and modern navy along with colonies to assume its Manifest Destiny as a leading power in the Pacific Ocean. Mahan also called for an isthmian canal allowing the navy easier access to America's coastal waters. Pres. Harrison tried to annex Hawaii for a naval base at Pearl Harbor, but the Senate refused to ratify the treaty. Great Britain, Germany, France, and Japan used Mahan's work as a textbook for their imperialistic plans.

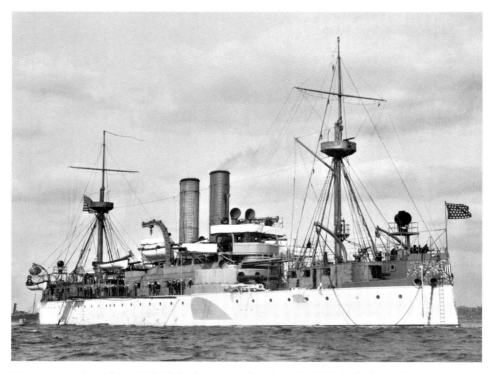

The construction of the USS *Maine* began on October 17, 1888 in the Brooklyn Navy Yard. The armored cruiser or second-class battleship was already obsolete when commissioned in 1895, one of the last with sail riggings. The Navy Act of 1890 approved the building of four modern battleships starting with the USS *Indiana*, named to honor the President's home state. By the turn of the twentieth century, the launching of more vessels brought the U.S. Navy's ranking from twelfth to fifth place in the world.

Protecting American interests, Harrison negotiated with Britain and Germany over the controversy involving the Samoan Islands. In 1877, M. K. Le Memea, a diplomat, had traveled from Samoa to Washington and signed a treaty. The United States gained control of Tutuila Island, where Pago Pago Harbor became a coaling station in the South Pacific. Until a typhoon struck in March 1889, tensions between America and Germany nearly led to a confrontation of warships. The following month, Harrison sent a delegation to a conference in Berlin. The treaty ratified in June 1890 guaranteed the spheres of influence besides the independence and neutrality of the Samoan government.

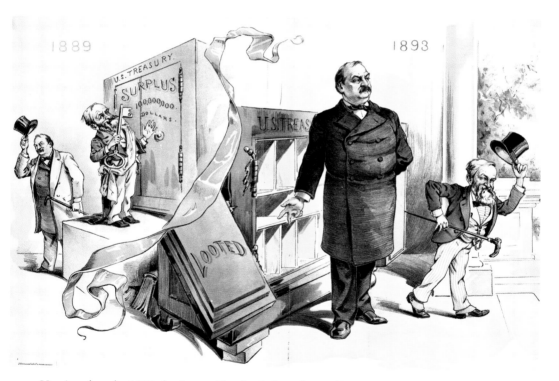

Harrison lost the 1892 election to Cleveland, the only president to serve two nonconsecutive terms. Harrison had entered the White House with the luxury of a large surplus in the treasury. Instead of reducing the high tariff, the Billion Dollar Congress appropriated more money for funding pensions and building a modern navy. The Democrats continued to oppose the protective tariff and increased pensions.

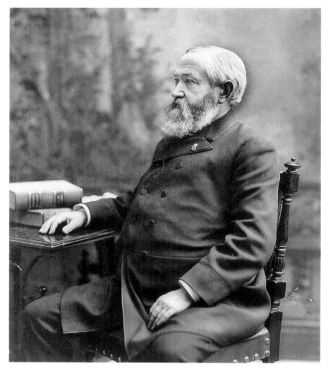

After leaving office, Harrison went to California and lectured on law at Stanford University. Political friends wanted him to be the nominee for president in 1896, but he turned them down and campaigned for William McKinley. At the time of his second marriage, he was serving as a trustee for Purdue University. During the 1898 session of an international court in Paris, he unsuccessfully represented Venezuela in a border dispute with British Guiana. However, Harrison's legal expertise brought him international fame, and the following year, he attended the first Hague Peace Conference.

Returning home to Indianapolis, Harrison worked as an elder for the First Presbyterian Church on a creed revision committee but illness prevented him from completing his last task of public service. A tireless schedule took its toll, and he died from pneumonia on March 13, 1901. Harrison was buried next to his first wife in Crown Hill Cemetery. Mary Harrison died in 1948 and was interned next to them. (*Wikimedia Commons*)

6

William McKinley

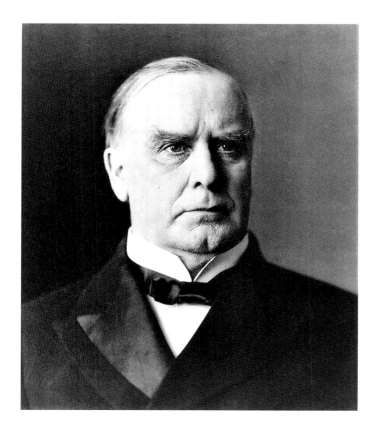

William McKinley, the twenty-fifth president, held office from March 1897 to September 1901. The American Political Science Association in 2018 gave him a rating of 55.5 percent, placing him at eighteenth of the forty-three presidents and first among those from Ohio.

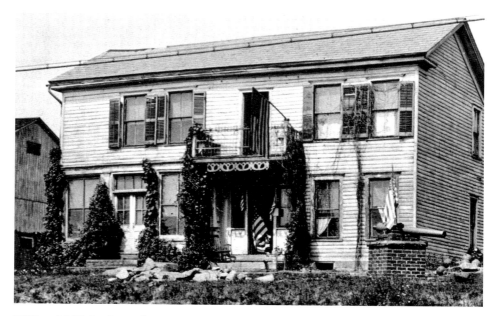

William McKinley Jr. was born on January 23, 1843 in this house at Niles, Ohio. His Methodist parents moved to Poland, Ohio because the schools would provide a better education for their children. He graduated in 1859 from Poland Academy and then attended Allegheny College in Meadville, Pennsylvania. After a year, he moved back home due to ill health. McKinley did not return to college because his father had financial problems. At the beginning of the Civil War, he was working in the Poland post office after teaching at a local school. (*Cleveland Public Library*)

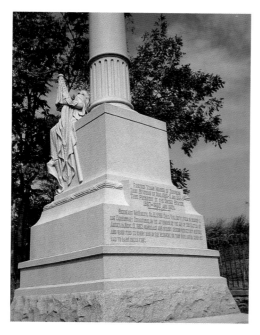

In June 1861, McKinley enlisted in the 23rd Ohio Infantry Regiment. He saw action in the late summer of 1862 at South Mountain, Maryland, under the command of Col. Ruther B, Hayes. Three days later, Sgt. McKinley fought in the bloodiest day of the war at Sharpsburg along Antietam Creek. A monument today commemorates his heroism on September 17, 1862, which led to a commission as a second lieutenant. After deployment in July 1863 to pursue Morgan in Ohio, his regiment campaigned in the Shenandoah Valley of Virginia a year later. He mustered out in June 1865 as a brevet major. (*Author's Collection*)

McKinley came home to Poland and studied law with a local attorney. He attended the Albany Law School in New York for about a year and passed the bar in Warren, Ohio. He then moved to Canton in 1867, and started a law practice with George W. Belden, a former judge who had campaigned for Rutherford B. Hayes running for governor. The young lawyer won his first election in 1869 for prosecuting attorney of Stark County but lost his attempt for another two years in office. McKinley married Ida Saxton in January 1871. In 1876, McKinley successfully defended a group of coal miners charged with attacking the strikebreakers. Mark Hanna was one of the mine owners in the case. McKinley's support for labor helped him win the election to the House of Representatives where he became a promoter of a higher protective tariff. The McKinley Tariff passed Congress in 1890.

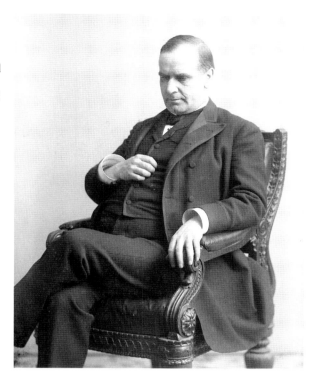

Democratic opposition to McKinley's tariff led to his defeat in the 1890 election. The following year, Ohio Republicans nominated him as their candidate for governor. Winning the election, he tried to be fair to workers in spite of his support of business, procuring an arbitration board to resolve labor disagreements and a law that fined management for firing workers because they joined a union. He objected when nearly 200 delegates voted for his nomination at the 1892 Republican National Convention.

Above: The worst depression in American history lasted from 1893 to 1897. The owner of a sand quarry in Massillon, Ohio, Jacob Coxey led a march on Washington starting on Easter Sunday 1894 to protest government inaction on the problem of high unemployment. Coxey's Army of about 500 arrived on the steps of the Capitol in May and peacefully demanded a public works program. Pres. Cleveland and Congress turned them down, and police arrested Coxey for trespassing on government property.

Below: Mark Hanna of Cleveland managed the campaign, which won McKinley the Republican nomination for president in 1896. On the first ballot, the delegates handed him the victory with 72 percent of the vote. A corporate lawyer from New Jersey, Garret A. Hobart became the vice-presidential nominee, another choice of Hanna. The platform called for a protective tariff and a gold standard.

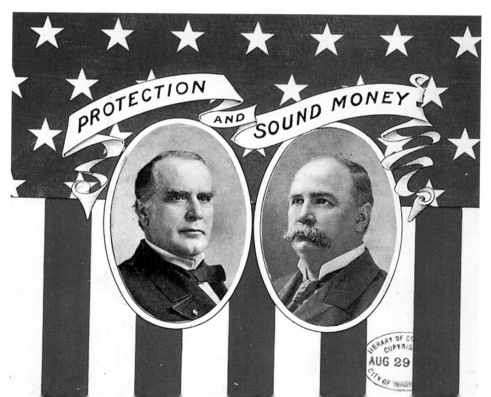

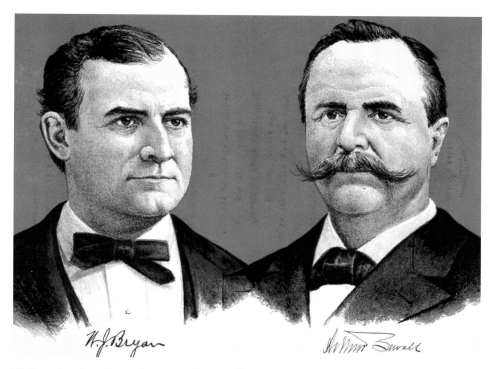

William Jennings Bryan, lawyer and orator from Nebraska, gave a stirring keynote address at the Democratic National Convention, leading to his unanimous nomination on the fifth ballot. At thirty-six years of age, he was the youngest nominee for president in history. His "Cross of Gold" speech condemned bankers and their allies in the East for the gold standard to the detriment of the average American. He wanted an increase in the coinage of silver to improve farm income in the Midwest. With little input from Bryan, the delegates came up with an unlikely, comprised candidate for vice president, Arthur Sewall, a wealthy businessman from Maine. The Populist Party, an agrarian party in the West and South, also nominated Bryan because of his support for more silver coinage.

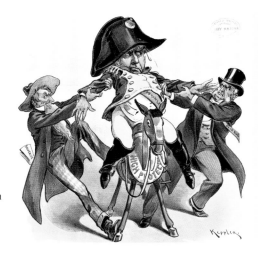

Unlike the protective tariff, McKinley did not want to take a firm position on the money question for fear of disrupting the solidarity of his party. He favored bimetallism (gold and silver) accomplished through an international agreement. Refusing to accept the monetary plank in the platform, a faction mainly from silver-mining states in the West formed the Silver Republican Party and nominated Bryan.

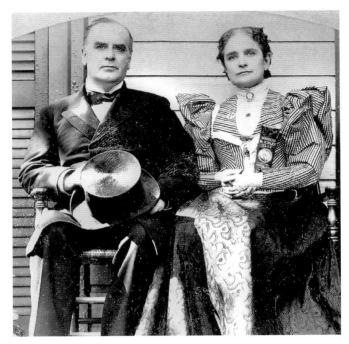

Ida McKinley sat next to her husband during his front porch campaign. Hanna wanted him to leave Canton and address crowds in the swing states. Knowing Bryan's ability as a stump speaker, McKinley knew he could not compete with him. He wanted his talks meticulously written to avoid unexpected questions. Visitors paid cheaper fares because of railroad subsidies. The Cleveland *Plain Dealer*, a Democratic newspaper, sarcastically reported that staying home was more expensive than going to Canton.

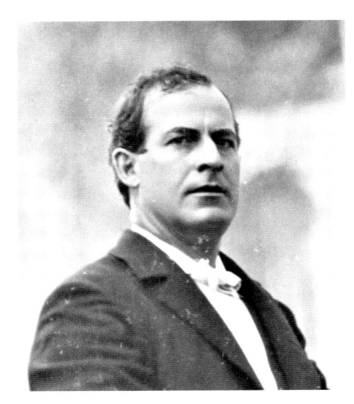

Bryan went on a whistle stop campaign in twenty-seven states, calling for the coining of silver at a sixteen to one ratio to gold. With evangelical speeches, he criticized the monopolistic banks, insurance companies, railroads, and other businesses. Republicans claimed he was a lunatic who would ruin the economy. Employers warned workers that they would be fired if Bryan were elected president. Conceding the West and South, Republicans were ahead in the Northeast but the Midwest appeared to be in doubt until late September.

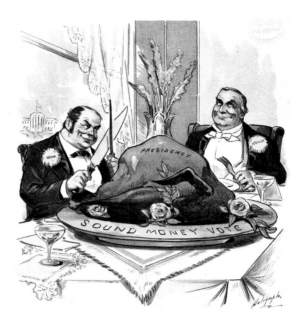

With the Republican victory, *Puck* portrayed Hanna and McKinley celebrating over their Thanksgiving turkey. McKinley won 51 percent of the popular vote and 60 percent of the electoral vote. As expected, Bryan captured the states in the West and South. Although losing some seats in the House, Republican maintained control and increased their majority in the Senate.

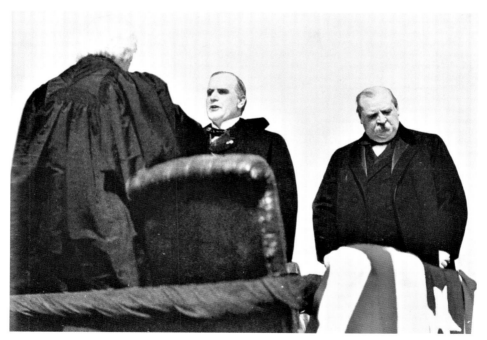

In March 1897, Chief Justice Melville Fuller swore in William McKinley as the twenty-fifth president. Grover Cleveland thoughts seemed to be elsewhere. McKinley defeated Bryan because he spoke for an urban, industrial nation while his opponent appealed to rural, small-town America. His inaugural address included tariff legislation being the first priority over the monetary matter. In foreign affairs, he opposed intervention and territorial acquisition.

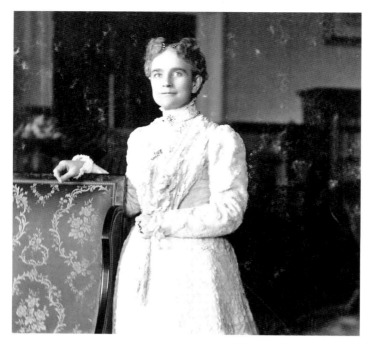

Ida McKinley posed for this picture in the White House. In the early 1870s, she lost her mother and two young daughters then came down with epilepsy. Mrs. McKinley always sat next to her husband during state dinners. If she had a seizure, he would routinely place a handkerchief or napkin over her face. The President's loving care for his wife brought admiration for him in Washington.

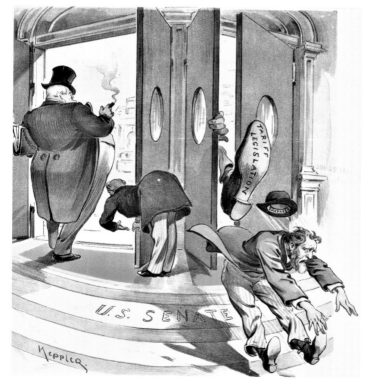

Averaging 52 percent, the Dingley Act of 1897 raised the protective tariff to the highest level in history. In the *Puck* cartoon, a fat monopolist entered the Senate while a shoe labeled "Tariff Legislation" kicked a taxpayer out the door. The Senate acquired the name of "Millionaire's Club." The next tariff legislation came twelve years later when Pres. Taft signed the Payne–Aldrich Tariff Act in 1909.

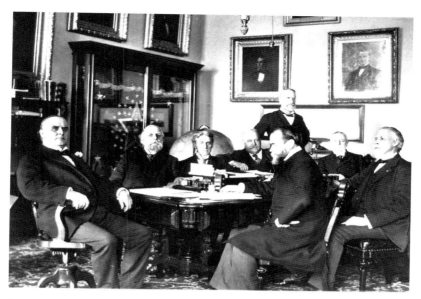

Pres. McKinley appointed Sen. John Sherman to be Secretary of State, making his vacated seat available for Mark Hanna. A year later, Sherman retired due to ill health. The President sat with his cabinet in 1898: back of table left to right, Treasury Sec. Lyman J. Gage, Attorney Gen. John W. Griggs, Navy Sec. John D. Long, Agriculture Sec. James Wilson (standing), and Interior Sec. Cornelius N. Bliss; front of table: State Sec. John Hay, War Sec. Russell A. Alger, and Postmaster Gen. Charles E. Smith.

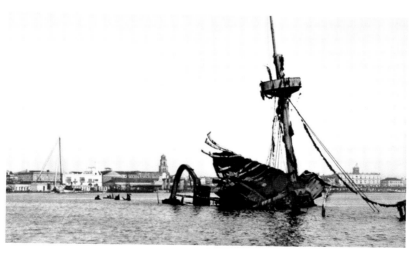

A Cuban rebellion against Spanish control started in 1895. As the revolt intensified, Pres. McKinley became concerned about the safety of U.S. citizens on the island. In January 1898, he ordered Navy Sec. Long to send the USS *Maine* from Key West to Havana. Three weeks later, an explosion destroyed the ship, which sank in the shallow harbor. Some 200 sailors died with six perishing from injuries. Many Americans blamed the Spanish for the disaster, but future investigations proved spontaneous combustion in a coal bunker ignited a nearby magazine.

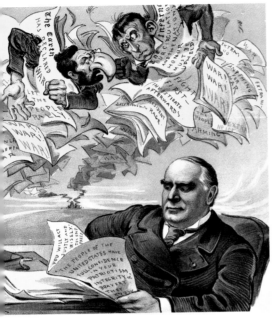

In a *Puck* cartoon, Pres. McKinley read a "decent press [praising him for] patriotism, integrity, and bravery." From left to right, a toucan represented Joseph Pulitzer of the *New York World* and a monkey represented William Randolph Hearst of the *New York Journal*. The newspaper publishers are flying in a whirlwind filled with demands for war and criticisms of the president. McKinley favored diplomacy, knowing the anti-war sentiments of most businessmen. However, Congress passed a joint resolution demanding Spain's withdrawal from Cuba and authorizing the president to use the military if necessary. On April 20, 1898, McKinley signed the legislation encouraged by the Teller Amendment guarantying Cuba would not become a U.S. colony after the war. Spain refused the ultimatum and broke off diplomatic relations, followed by a declaration of war after the U.S. Navy blockaded Cuba. Congress reciprocated on April 25.

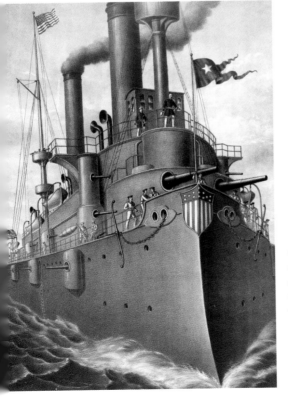

Cdr. George Dewey looked down from the bridge of his flagship the USS *Olympia* during the Battle of Manila Bay on May 1, 1898. Four days earlier, Sec. Long sent a message to Dewey, commanding the Asian Squadron in Mirs Bay on the coast of China. He ordered him to attack the Spanish fleet in the Philippine Islands. Dewey easily defeated the Spanish in a six-hour battle. In the meantime, Emilio Aquinaldo's Filipino nationalists captured Manila and welcomed the Americans as liberators.

Assistant Navy Sec. Theodore Roosevelt resigned and joined the First United States Cavalry Regiment training near San Antonio, Texas. After Col. Leonard Wood assumed command of a brigade, Col. Roosevelt took over control of the regiment, nicknamed the Rough Riders. They left for Tampa, Florida at the end of May and then waited a month until sailing without their horses on the *Yucatan* to Cuba. Untrained as infantry, the regiment with other units fought the Spanish in the victory at Las Guasimas on the road to Santiago. Spanish soldiers on July 5, 1898 occupied a strong position on the San Juan Heights, which the Americans attacked suffering heavy casualties. Leading his men, Roosevelt ordered them to charge, and the Rough Riders overwhelmed the enemy at the top. In the meantime, the U.S. Navy defeated the Spanish fleet in the Battle of Santiago Bay. The city capitulated on the 17th, and Spain surrendered on August 12.

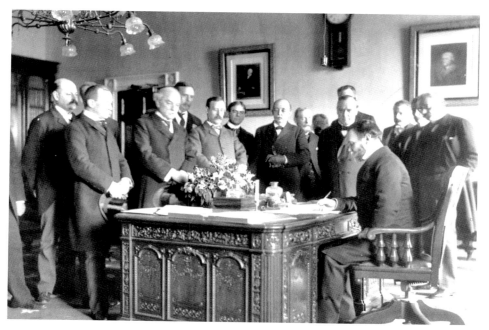

Diplomats from the United States and Spain met in Paris to negotiate a peace treaty in the autumn of 1898. In the White House on April 15, 1899, Pres. McKinley watched Sec. of State John Hay sign the ratification memorandum for the Protocol of Peace. Spain abandoned its rights in Cuba besides ceding to the United States the Philippines, Guam, and Puerto Rico. During the war, the strategic importance of Hawaii led to annexation by a joint resolution of Congress signed by McKinley. Entering the twentieth century, America was now a world power.

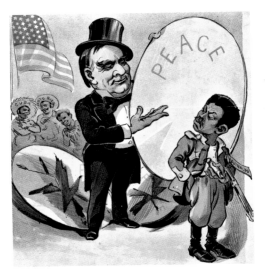

A guerrilla war broke out in February 1899 when Emilio Aquinaldo's Filipino nationalists revolted against American annexation of the Philippine Islands. Pres. McKinley assumed the insurrection would be easily defeated, but the hostilities continued for over three years, resulting in more American casualties than the war against Spain. Philippine deaths among combatants and civilians were extremely high, causing criticism in the United States. At the same time, the president had another foreign policy concern in China.

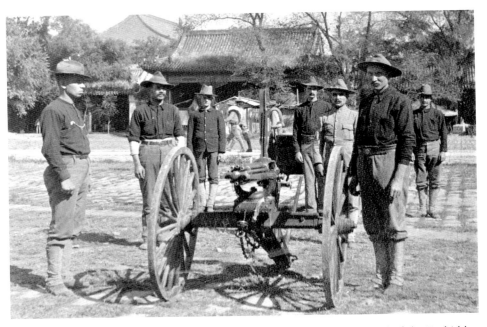

The Ninth U.S. Infantry Gatling Gun Detachment occupied the courtyard of the Forbidden City in Beijing, China. In January 1899, the Boxer Rebellion started in China because of foreign influence in the country. Boxers burned churches besides killing Chinese Christians and Western missionaries, some of whom were from Oberlin College in Ohio. The diplomats in Beijing feared for their lives and asked for help. Eventually, troops from the United States, United Kingdom, Russia, France, Japan, Germany, Italy, and Austria-Hungary fought their way to Beijing and put down the siege. Casualties included 32,000 Chinese Christians, 200 Western Missionaries, 2,500 foreign soldiers, and unknown numbers of Boxers. On September 7, 1901, the Chinese government agreed to pay repatriations to the Eight Nation Alliance.

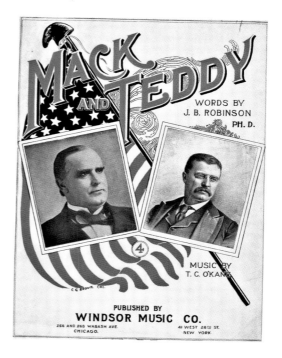

With the death of Vice Pres. Garret A. Hobart, McKinley left the choice of a new running mate to the delegates at the 1900 Republican National Convention. Awarded the Medal of Honor, Roosevelt became a national hero and won the election for Governor of New York. Sen. Hanna objected to nominating Roosevelt because he was erratic and against the political bosses in New York. Endorsing Roosevelt for vice president, Sen. Thomas C. Platt of New York wanted the governor out of the way. The Republicans campaigned less on the gold standard and more about prosperity at home and victory overseas.

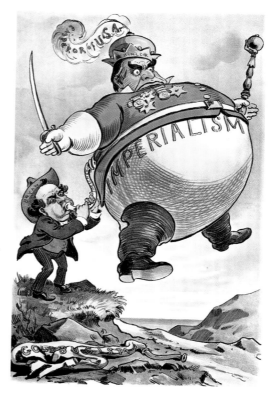

Bryan again opposed McKinley in the election for president. Most of the criticism about the peace treaty came from the Democrats. However, realizing the popularity of the war, he focused more on McKinley being a puppet of big business at the expense of the average American. He went on a whistle-stop tour around the country bringing his message to the voters and accusing the president of replacing a brutal Spanish dictatorship with an American one carrying on a harsh war against Filipino nationalists.

Above: As before, McKinley campaigned from his front porch in Canton, but now soldiers protected him from unpredictable crowds. In 1900, he had a dynamic running mate making appearances across the nation. Roosevelt played a significant role in the president's reelection because he drew large crowds with his heroic image and forceful speeches. The Rough Rider was paving the road for his own run for the White House in 1904.

Below: McKinley won the greatest Republican victory for president since Grant in 1872. His 1901 inaugural address compared the present state of the nation with conditions when he took office in 1897. The depression had turned to prosperity and the Treasury went from a deficit to a surplus. He wanted to avoid war but now the victory imposed upon the nation an obligation that would be dishonorable to escape. He then pledged to uphold the gold standard and a protective tariff over the next four years.

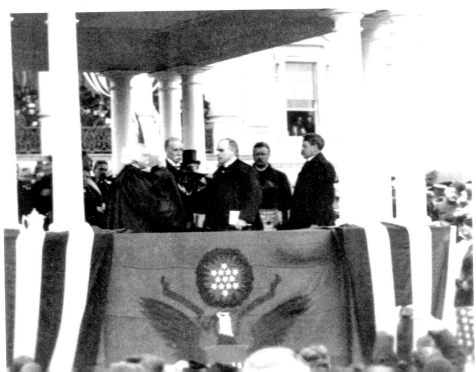

Above: After the inauguration, McKinley and his wife toured the West. He took part in the launching of the USS *Ohio* in San Francisco. The battleship joined the new fleet authorized by Pres. Harrison. A working vacation, he planned making speeches on trade reciprocity in California. Ida McKinley, however, became ill, and they returned to Washington after canceling the public appearances.

Right: Fred R. Hamlin produced a musical version in 1902 of L. Frank Baum's novel *The Wonderful Wizard of Oz*. More than likely, the story was an allegory of politics at the turn of the twentieth century: "oz" was the standard unit of measurement for gold and silver; Kansas, the Populist stronghold; Yellow Brick Road, the gold standard; and the Wicked Witch, monopolists. Dorothy and her group symbolized Coxey's Army: The Tin Woodsman, a dehumanized factory worker; the Scarecrow, a naive farmer; and the Cowardly Lion, Bryan. They sought help from the Wizard, Pres. McKinley, in the Emerald City—Washington.

FRED R. HAMLIN'S MUSICAL EXTRAVAGANZA

THE **WIZARD** OF **OZ**

· THE TIN MAN ·

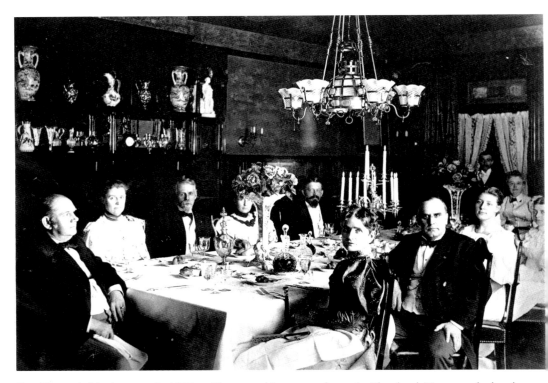

Sen. Hanna held a banquet in 1901 at Glenmere, his summer home in Cleveland. He sat at the head of the table with wife Charlotte on his left. Ida McKinley sat to the right next to her husband. Over the years, Hanna and Pres. McKinley spent many hours in the house planning campaign strategies. Lake erosion destroyed Glenmere, and the former site lies off the shore of Perkins Beach in the Edgewater Reservation of Cleveland Metroparks. (*Cleveland Public Library*)

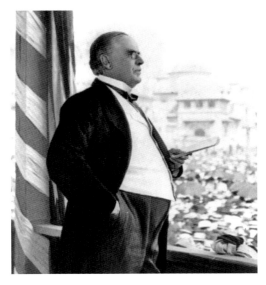

Pres. McKinley liked meeting the public, but George B. Cortelyou, his personal secretary, worried about the President's safety. Anarchists had recently murdered European leaders including the King of Italy. Cortelyou wanted to cancel the President's appearance at the Pan American Exposition in Buffalo. Unconcerned, he gave a speech in Buffalo on September 5, 1901 and the next day shook hands with people in a reception line at the Temple of Music. Leon Czolgosz approached him with a handkerchief concealing a revolver in his right hand. He fired two shots into McKinley's abdomen. Some of the crowd attacked the gunman and nearly killed him. Aids took the President to the Milburn House where he had been staying with his wife, and he died there nine days later.

Police found a picture of Czolgosz among his possessions in Buffalo. He was born of Polish parents on May 5, 1873 in Michigan and moved at the age of seventeen years to Cleveland. Czolgosz lived in a Slavic neighborhood and worked at the nearby Cleveland Rolling Mill Company. The depression left him without a job in 1893. Frustrated with an unjust society, he attended radical meetings and then lived on his father's farm in Warrensville, Ohio. In May 1901, he heard Emma Goldman give a highly charged talk on Anarchism at a rally in Cleveland. In the cause for the exploited masses, Czolgosz decided to kill McKinley, symbol of the wealthy class in America. After a trial questioning his sanity, the jury found him guilty, and he died in the electric chair on October 29, 1901.

Leaving the Wilcox House in Buffalo, Pres. Roosevelt talked to Sen. Hanna while Henry Cabot Lodge walked behind them. Roosevelt had just taken the oath of office on September 14, 1901. A week earlier, he thought McKinley would recover and left Buffalo to resume a camping trip in the Adirondacks. He quickly returned on hearing about. the President's critical condition.

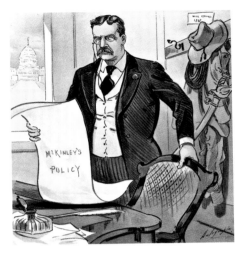

At the age of forty-two years, Roosevelt became the youngest president in history. He promised to follow the policies of his predecessor, keeping the same members of the cabinet. Losing a close friend, Hanna complained that "damn cowboy" was now president of the United States. He worried about Roosevelt's impulsive behavior and reform-mindedness. Along with Republicans and Democrats, *Puck* wondered about Pres. Roosevelt's plans for the future.

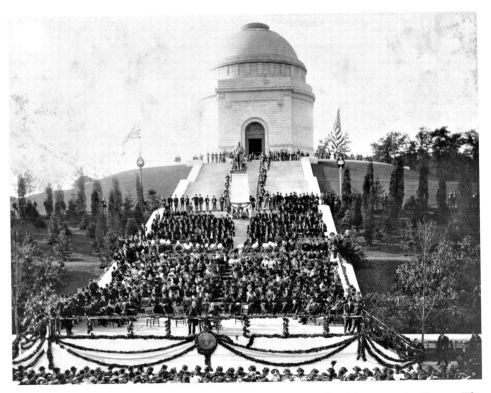

On September 30, 1907, Pres. Roosevelt dedicated the McKinley Monument in Canton. The tomb is the final resting place for William and Ida McKinley and their two daughters. Mrs. McKinley never left Canton after returning from Washington in 1901. She died in May 1907 after suffering a decline in health brought on by her husband's assassination. Established on January 31, 2001, the First Ladies National Historic Site in Canton includes the Ida Saxon McKinley Home besides a museum and library.

7

William Howard Taft

William Howard Taft, the twenty-seventh president, held office from March 1909 to March 1913. The American Political Science Association in 2018 gave him a rating of 52 percent placing him at twenty-second of forty-three presidents and third among those from Ohio.

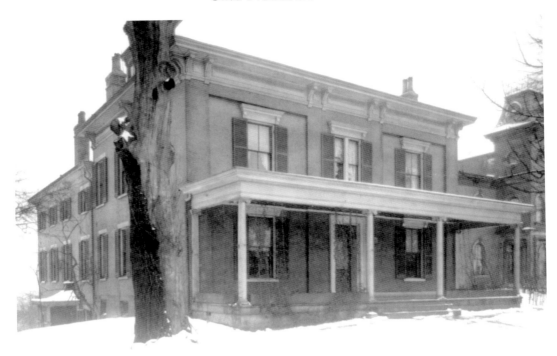

William Howard Taft was born on September 15, 1857 in Cincinnati, Ohio. Today, the Taft Home, the place of his birth, is a National Historic Site. His father Alphonso Taft was a judge who became War Secretary and then Attorney General in Pres. Grant's cabinet. Afterwards, Pres. Arthur appointed him Minister to Austria-Hungary. To please his demanding father, William studied conscientiously at Woodward High School in Cincinnati. He played on the baseball team and graduated second in his class in 1874. On the occasion, he gave a speech on female suffrage inspired by his mother.

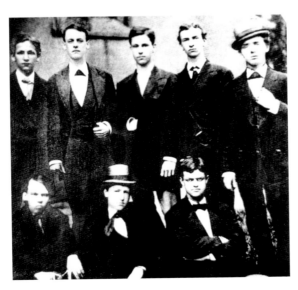

While attending Yale University, his father told him to give up sports and concentrate on academic studies. In the picture, Taft sits in the middle of the first row. He was popular among his classmates who remembered him as good-humored and studious. Taft like his father joined the Skull and Bones Secret Society. Graduating second in his class, he enrolled in the Cincinnati University Law School and worked part time for the *Cincinnati Commercial* as a reporter in the county courthouse. Taft passed the bar exam at Columbus, Ohio in May 1880.

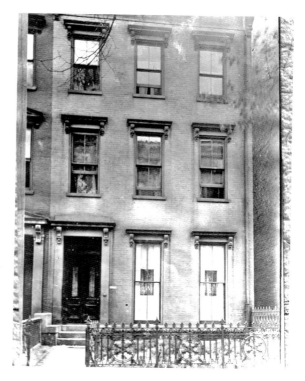

Taft probably met Helen Herron on the campus of Cincinnati University. She was born on June 2, 1861 and lived in a Cincinnati townhouse owned by her father. Judge John W. Herron had attended college with Benjamin Harrison and practiced law with Rutherford B. Hayes. Her mother's father and uncle served in Congress. In 1877, the Herron family spent a week in the White House when Rutherford and Lucy Hayes celebrated their twenty-fifth wedding anniversary.

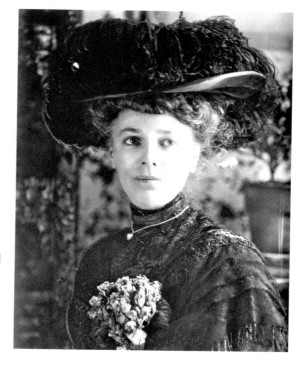

Helen Herron taught in local schools for four years before her marriage. In the Herron home, William and Helen Taft were married on June 19, 1886, and they went to Europe for a three-month tour. She became an important influence and supporter of her husband's political and judicial careers during their almost forty-four years together. They had three children: Robert, Helen, and Charles.

Above: The Federal Court Building in Cincinnati dates from 1885. Taft's rise in public office began as an assistant prosecutor for Hamilton County in 1880. Pres. Chester A. Arthur appointed him in January 1882 to be collector of internal revenue for Ohio's First District, but after a year, he resigned over pressure to fire competent workers for political reasons. He returned to his law practice and helped Blaine's presidential campaign in 1884. Entering public service again, he became a judge for the Superior Court in Cincinnati. Pres. Harrison made him solicitor general of the United States in 1890. After Congress created the Federal Court of Appeals, Taft left Washington in 1892 to serve as judge for the Sixth Circuit Court in his hometown.

Below: In January 1900, Pres. McKinley asked Taft to chair a commission for organizing a civil government in the Philippines. He accepted with the promise of an appointment to the next vacancy on the Supreme Court. Taft with his wife and their children left the United States in April. During the long voyage to the Philippines, the Tafts played cards with a naval officer and a passenger who kept score.

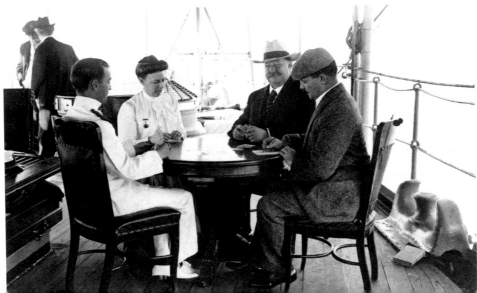

Taft had a difficult job ahead of him. Gen. Arthur MacArthur, Jr. was the military governor who saw Taft as a pest with idealistic goals. In July 1901, McKinley made Taft the civilian governor and assigned MacArthur to a position in the United States. Taft started a program to help prepare the Filipinos for self-government in the future. He had to confront the prejudice among Americans living in the Philippines. In addition, he thought farmers would support the government if they worked on their own land. However, the Catholic Church owned most of the arable land. Taft went to Rome in 1902 and successfully negotiated with the Vatican to sell the land and replace Spanish priests with Filipinos.

Helen Taft wore Filipino clothes and respected the culture of the Philippines, believing that neither race nor class should influence hospitality. She held social gatherings, which included Americans and Filipinos. Her children attended schools in Manila. She saw their time abroad as a unique learning experience for her sons and daughter. When Pres. Roosevelt offered him the position of War Secretary, Taft consulted with her, and she thought he should accept the next step in his political career.

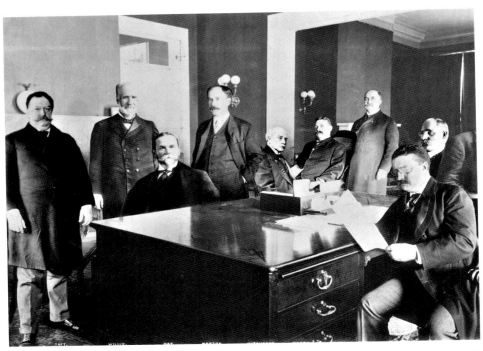

Standing on the far left, Taft joined Roosevelt's cabinet in January 1904. The President wanted Taft to be an administrator of the army as well as an advisor on legal matters and someone to represent him in public appearances. An election year, Taft made speeches for Roosevelt's campaign. Republicans were now looking at Taft to be their candidate in 1908, but he hoped someday to be Chief Justice of the Supreme Court.

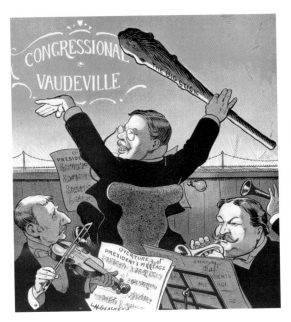

Puck saw Congress as a vaudeville act. The President conducted the cabinet band as Taft played a trumpet. Roosevelt's "big stick diplomacy" resulted from his corollary to the Monroe Doctrine. He sent troops into Latin America to maintain stable governments friendly to the United States. Interfering in the Panamanian revolt against Colombia, he established the Canal Zone in 1903 at the Isthmus, while the Senate had yet to ratify the treaty.

The digging of the Panama Canal was just beginning in 1905. A year earlier, Roosevelt put the War Department in charge of the canal project and sent Sec. Taft to Panama for inspecting the site and meeting with the government of Panama. The chief engineer of the project, John Stevens, resigned over government bureaucracy in February 1907. Taft chose Col. George W. Goethals, an army engineer who would complete the canal ahead of schedule in 1916.

In July 1905, Mr. Nagasaki greeted Sec. Taft on the dock at Yokohama, Japan. On the far right, the President's daughter, Alice Roosevelt, accompanied Taft on the trip. He met with Prime Minister Katsura Taro to sign a memorandum in which the United States acknowledged the Japanese dominance in Korea. Japan officially accepted America's control of the Philippines. During Taft's next visit in 1906, he concluded an agreement limiting the number of Japanese laborers coming to America.

Taft's first diplomatic mission included Roosevelt's offer to mediate an end to the Russo-Japanese War. At the time, the nation celebrated the defeat of Russia, the first victory over a European country in history. Roosevelt arranged a meeting between the belligerents in Portsmouth, New Hampshire. After a month of negotiations, they signed a peace treaty on September 5, 1905. Neither nation was pleased with the outcome, placing some of their criticism on Roosevelt who would win the Nobel Peace Prize.

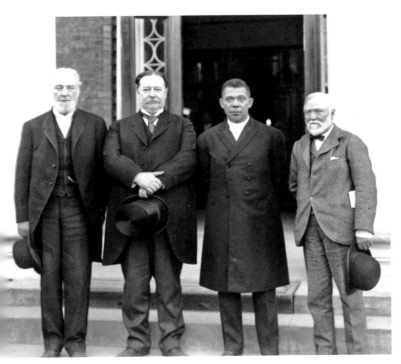

In Alabama, the Tuskegee Institute observed its twenty-fifth anniversary in 1906. Left to right: Robert C. Ogden, Taft, Booker T. Washington, and Andrew Carnegie celebrated the event. Carnegie, Ogden, and other philanthropists provided financial support for the education of African Americans in the South. For the occasion, Mark Twain spoke at Carnegie Hall in New York City to honor Washington, founder and president of the institute.

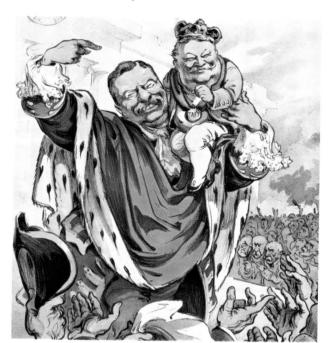

Later regretting his promise, Roosevelt pledged not to run again for the presidency after winning the 1904 election. He believed Taft would continue to support his agenda. Taft had misgivings at first but changed his mind after giving speeches on a tour of the Midwest. Delegates at the 1908 Republican National Convention in Chicago nominated him on the first ballot. He resigned from the cabinet before campaigning.

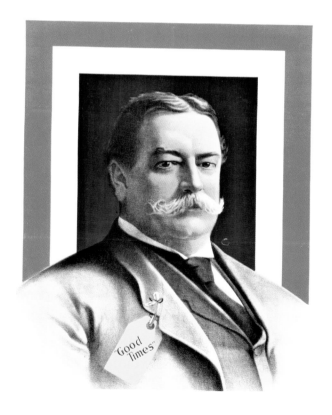

Critics said the nominee was really a stand-in for Roosevelt after Taft went to see him for advice at Sagamore Hills. Nevertheless, he backed most of the president's policies including stricter regulation of trusts, limits on railroad rates, labor's right to organize, and flexibility of the money supply. Taft supported the expansion of executive power but saw the need for legislative endorsement. Progressives in the party questioned his choice of Frank Hitchcock, a conservative, to be the chair of the Republican National Committee.

William Jennings Bryan campaigned for the presidency with the motto: "Shall the People Rule?" He crusaded against the influence of the wealthy in Washington and less about the coinage of silver. Bryan claimed Roosevelt's progressive agenda came from his proposals. He wanted the government to ensure bank deposits and take over the ownership of the railroads. Socialist Eugene V. Debs's candidacy took votes away from Bryan, as did the liberal planks in the Republican platform.

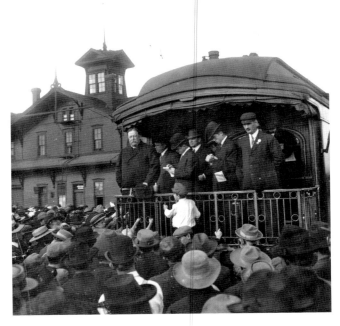

Both candidates made whistle-stop speeches in the Midwest and West. In August, Taft decided to take a golfing vacation at Hot Springs, Virginia. An irritated Roosevelt warned him that Bryan could win the election. Helen Taft objected to the President's interference in her husband's campaign. Carrie Nation wanted to know Taft's opinion on prohibition, but he remained neutral on the controversy. Taft easily won in the Electoral College but the popular vote proved to be closer.

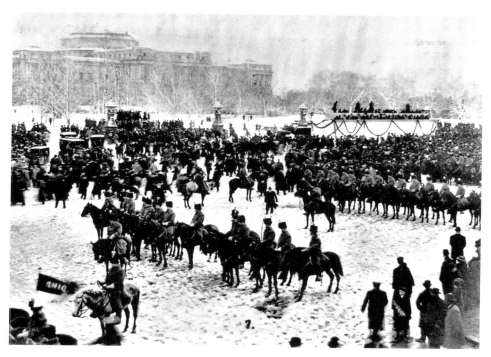

On a wintry day in March 1909, Ohio National Guard soldiers assembled for the inaugural parade. The swearing-in ceremony took place inside the Capitol because of the weather. Taft pledged to uphold the party platform and Roosevelt's reforms in his address. Staying away from politics for a year, Roosevelt vacationed out of the country. Unlike his predecessor, Taft would not have the same rapport with the press as Roosevelt. He was less dramatic and granted fewer interviews.

Uncle Sam wondered if the alarm on the clock was broken. It had not rung to signal Taft was following Roosevelt's policies. A passionate conservationist, Roosevelt began to have concerns when Taft replaced Interior Sec. James H. Garfield with Richard A. Ballinger. Suspected of conflicts of interest, he had served as commissioner for the General Land Office. Chief Forester Gifford Pinchot remained in office until Taft fired him because of a heated disagreement with Ballinger. Roosevelt and his followers began to believe the President no longer supported the Progressives in the party. *Puck* saw Taft as a clock-watcher, wondering about Roosevelt's homecoming in the near future.

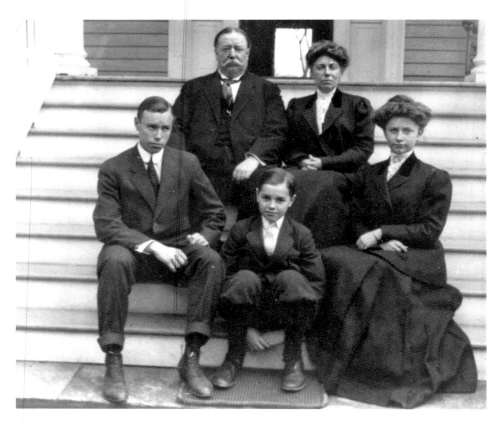

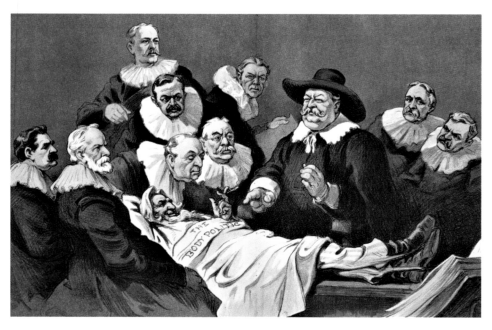

Pres. Taft went on a cruise in July 1910 aboard the USS *Mayflower*, which Roosevelt made the presidential yacht in 1905. He rarely used the vessel but this time sailed along the coast of Maine for ten days to escape the heat of summer and the stress in Washington. He preferred traveling by automobile or train to the Summer White House in Beverly, Massachusetts.

Opposite above: The President's family at Beverly, Massachusetts posed for a picture in July 1909. Pres. Taft and his wife sat behind their children from left to right: Robert A. Taft became a conservative Senate from Ohio and failed three times to be the Republican nominee for president; Charles P. Taft served as mayor of Cincinnati; and Helen H. Taft joined the Suffragette movement and married Frederick J. Manning, a history professor at Yale. Still recovering her health, Mrs. Taft suffered a mild stroke in May.

Opposite below: *Puck* turned Rembrandt's *The Anatomy Lesson of Dr. Nicolaes Tulp* into a parody of Taft's cabinet: First row left to right: War Sec. Jacob M. Dickerson, Agriculture Sec. James Wilson, State Sec. Philander C. Knox, Treasury Sec. Franklin MacVeagh, and Commerce Sec. Charles Nagel; Second row: Interior Sec. Richard A. Ballinger, Navy Sec. George von L. Meyer, and Postmaster Gen. Frank H. Hitchcock.

Puck saw Pres. Taft as an uncaring umpire in a football game. Pointing to Aldridge, the Plain people said, "He slugs me every chance he gets and you can't or won't see it." A Republican from Rhode Island, Sen. Nelson W. Aldridge sponsored a conservative tariff bill in the Senate to replace the reform bill in the House. The Payne–Aldrich Tariff Act increased the protective tariff. Progressives in the party blamed Taft, who believed the decision should be in the hands of Congress. The debate between the Old Guard and Progressives split the party and led to defeats in the 1910 congressional election.

A grumpy Uncle Sam looked into the mirror while shaving with a safety razor, symbolizing Pres. Taft. *Puck* implied he would go back to using Roosevelt's straight razor. Returning to America, Roosevelt thought Taft's presidency had not lived up to expectations by being too cautious and giving up leadership to Congress. He felt the nation's aspirations in domestic and foreign affairs needed a strong president in office.

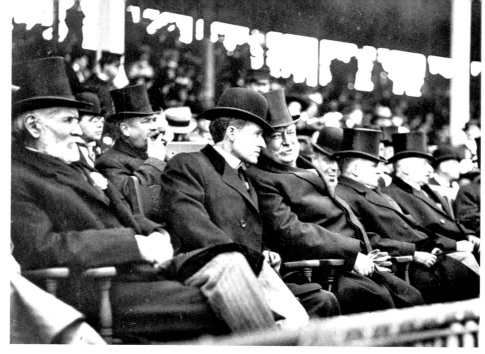

Above: On April 14, 1910, Taft became the first president to throw out the first ball of the baseball season, which he then autographed for Walter Johnson of the Washington Senators. Johnson donated the ball to the Baseball Hall of Fame in 1939. During the game, Taft talked to Walter L. Fisher, the next Secretary of the Interior. Speaker of the House Joe Cannon sat on the far left. Johnson pitched a one hit shut out to the delight of the 14,000 spectators at American League Park. At the time, the President's brother, Charles Taft, owned the Philadelphia Phillies in the National League.

Opposite above: At the White House in late June 1912, Taft received official notification of his re-nomination for president. The Republican National Convention was the most dramatic in the party's history. Roosevelt did well in the primaries with victories in nine states. While Taft prevailed only in Massachusetts, Sen. Robert M. La Follette, a reformer from Wisconsin, won two states. The stage was then set for the convention in Chicago. Taft had the support of most delegates chosen by state and district conventions. In addition, he controlled the party officials who made procedural decisions unfavorable to Roosevelt. As a result, Roosevelt and his delegation walked out of the convention. Taft warned that radical Progressivism would ruin the nation.

Opposite below: On August 28, 1912, *Puck* published "The Call" three weeks after the Progressive Party nominated Roosevelt for president and Gov. Hiram Johnson for vice president. Roosevelt said he felt like a Bull Moose as the New Nationalism platform called for political, economic, and social reforms. The Constitution needed three amendments for the direct election of the Senate, levying of an income tax, and suffrage for women. The party wanted a social insurance system for the elderly, disabled, and unemployed. Other economic measures included an eight-hour day, injured workers compensation, inheritance tax, tariff reduction, and farm relief. The topic of trusts and large corporations divided the party over a course of action. As a result, Roosevelt replaced breaking them up with stronger government regulation. On October 14, 1912 in Milwaukee, a saloon keeper shot Roosevelt in the chest, but he finished his speech. The bullet went through a book in his breast pocket and remained in him for the rest of his life.

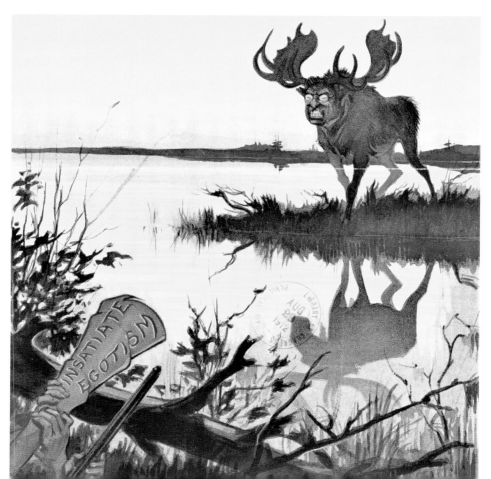

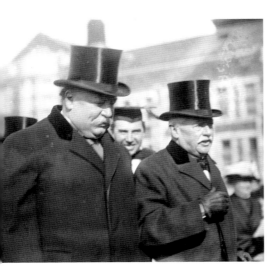 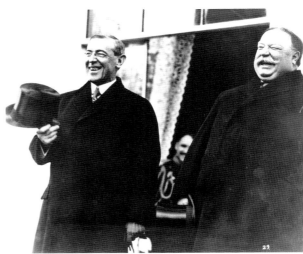

Above left: A week after the election, Taft attended a reception in New York to honor Dr. Alexis Carrel, winner of the Nobel Prize in medicine. Dr. John H. Finley, president of City College, walked with him. Taft had made only one campaign speech knowing he had no chance of reelection. He won Vermont and Utah while Roosevelt carried six states. Woodrow Wilson, Governor of New Jersey, was victorious with 82 percent of electoral votes and 42 percent of the popular votes. The Republican Party's division led to the election of only the second Democratic president since the Civil War.

Above right: After his inauguration in 1913, Pres. Wilson and Taft enjoyed a good laugh at the White House. The new president's reforms borrowed from Roosevelt's campaign proposals. Since former presidents did not receive a pension, Taft thought of returning to private law practice until Yale made him the Kent Professor of Law and Legal History. Serving a year as president of the American Bar Association, he also authored articles and a book besides giving speeches.

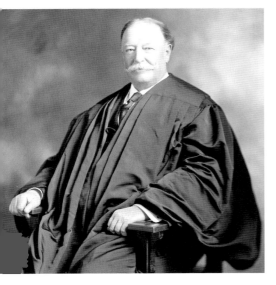

Taft campaigned for Republican nominees for president: Charles Evan Hughes in 1916 and Warren G. Harding in 1920. On June 30, 1921, Pres. Harding appointed him Chief Justice of the Supreme Court, an office he coveted more than president. For nearly nine years, Taft usually concurred with his conservative justices nullifying laws to regulate business. He lobbied successfully for a Supreme Court building separated from the Capitol. He died a month after resigning in February 1930 due to poor health. His grave is in Arlington National Cemetery.

8

Warren Gamaliel Harding

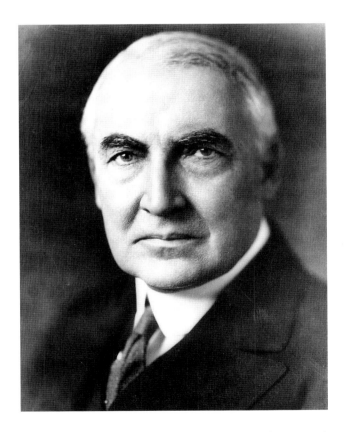

Warren Gamaliel Harding, the twenty-ninth president, held office from March 1921 to August 1923. The American Political Science Association in 2018 gave him a rating of 25.3 percent, placing him at thirty-eighth of forty-three presidents and seventh among those from Ohio.

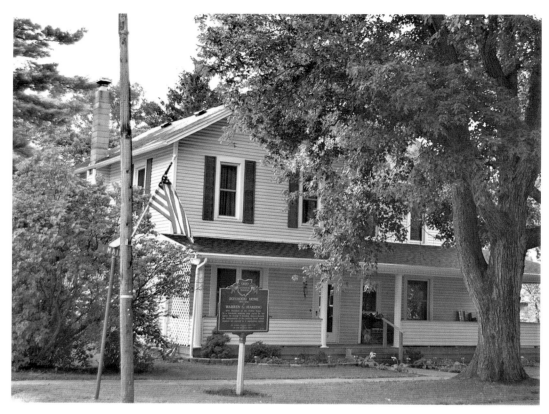

Above: Harding was born on November 2, 1865 in Blooming Grove, Ohio, near Caledonia where a historical marker stands in front of his boyhood home. At an early age, he acquired an interest in journalism while spending time at his father's newspaper, *The Argus*. In his controversial 1968 biography *The Shadow of Blooming Grove: Warren G. Harding in His Times*, Francis Russell perpetuated the rumor that Harding had an African American ancestor. DNA testing in 2015 proved Harding to be the father of Nan Britton's illegitimate daughter, and the rumors about his forebears were incorrect. (*Courtesy of Nyttend*)

Opposite: Harding proofread an article for his newspaper *The Marion Star* in 1910. He had attended Ohio Central College in Iberia and after graduation in 1882 joined his family who had moved to Marion. Briefly teaching and selling insurance, he purchased the failing newspaper for $300. He attended as a journalist the Republican National Convention in 1884, where he met prominent reporters and returned home supporting the nominee James G. Blaine. With cleverness, manipulation, and good luck, Harding transformed *The Marion Star* into a successful and an influential newspaper in Marion. He tried to be nonpartisan editorially since the city usually voted Republican, but the county was Democratic. As the city tripled its population to 12,000 by the turn of the century, he promoted the growth and made profitable real estate investments.

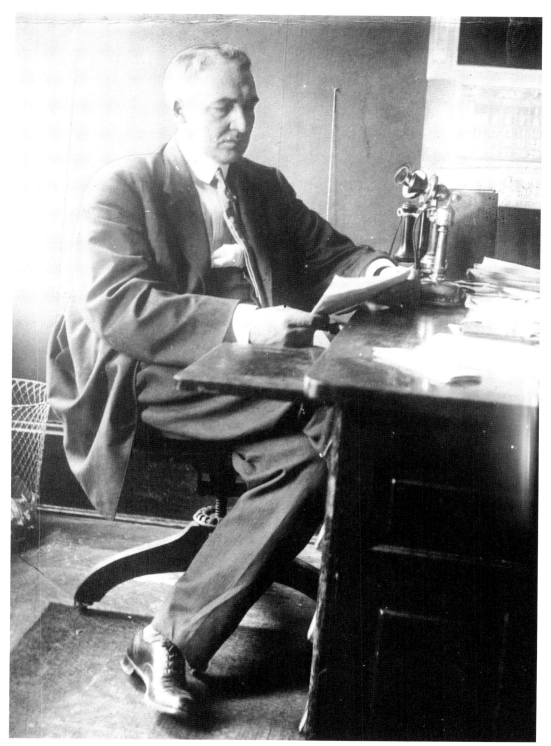

Daughter of a prominent banker, Florence Mabel Kling was born on August 15, 1860 in Marion. Florence's first marriage to Henry De Wolf ended in divorce. They had a son Marshall De Wolf. Five years his senior, she married Harding in 1891 despite the objections of her father who saw him as a social climber. Florence became the business manager of *The Marion Star* and improved the overall operation of the newspaper. Following emergency surgery in 1905, her long convalescence led to Harding having an affair with her good friend Carrie Phillips. She considered divorce since his indiscretions also included other women.

With the encouragement of his wife, Harding served as state senator and then lieutenant governor from 1900 to 1906, accepting the patronage and graft of the era. He spoke at Republican National Conventions and campaigned for the party's candidates. At the 1912 convention, he gave a nominating speech for Pres. William A. Taft. Two years later, under the newly ratified Seventeenth Amendment to the Constitution, Harding became the first Ohio senator elected by popular vote. An old friend and Democratic candidate, Timothy Hogan, a Roman Catholic, had faced absurd charges from Nativists that if elected, the Pope and Knights of Columbus would control Ohio. In his campaign, Harding avoided such charges in his speeches but did not condemn the prejudice.

At the top of the picture, Carrie Phillips toured Venice in 1912. Her affair with Harding continued for some fifteen years. James Phillips her husband owned a store in Marion and associated with the Hardings. Mrs. Phillips lived in Germany for a number of years and had pro-German opinions before and during World War I. She criticized Harding for playing politics with his anti-German votes in the Senate. He thought her conclusions were unfair, but their romance continued. Prior to his vote for war in April 1917, Phillips had hinted she might expose the senator's marital infidelities if he supported the resolution. Later, he cautioned her to be careful about speaking out against the war since she could be charged with violating the Espionage Act. (*Phillips/Mathee Collection, Library of Congress*)

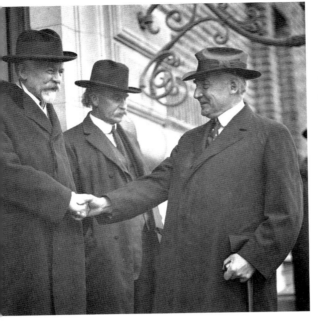

While Sen. Frank B. Brandegee looked distracted in the background, Henry Cabot Lodge, senator and historian from Massachusetts, shook hands with Sen. Harding in 1915. The Democrats controlled both houses of Congress and Woodrow Wilson occupied the White House. Three years later, congressional elections gave the Republicans a two-seat majority in the Senate but remained a minority in the House. As a result, Lodge took over the chair of the Senate Foreign Relations Committee. Sharing Lodge's policies, Harding became a member of the committee, which included nine Republicans and eight Democrats.

Sen. Harding and Sen Calder left Washington in June 1920 for the Republican National Convention in Chicago. With the death of Theodore Roosevelt, a number of candidates sought the nomination including Sen. Hiram Johnson and Gen. Leonard Wood. Conservative delegates viewed Johnson and Wood as too progressive, preferring instead someone less liberal. Harding's campaign manager, Harry M. Daugherty had a plan. If the balloting reached a deadlock, he would meet with the Old Guard and suggest Harding as a compromise candidate. After the ninth ballot, the convention nominated the junior senator from Ohio.

In January 1919, Pres. Wilson went to the Peace Conference in Paris without taking any Republicans from the Senate Foreign Relations Committee. Returning to the country, he appeared in July before the committee for its advice and consent in regards to the Treaty of Versailles, the peace settlement with Germany. The League of Nations was the most controversial part of the treaty. Wanting changes in the charter, the GOP senators feared Congress would be surrendering too much authority to the League. The Lodge Reservations were accepted by a vote along partisan lines. Wilson refused to make any changes and went on a speaking campaign during which he suffered a stroke. The Senate never approved the Treaty of Versailles.

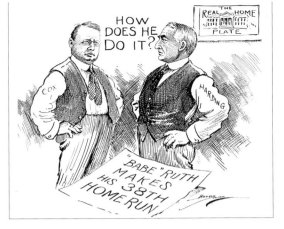

Above left: During a May speech in Boston, Harding said the nation needed a return to "normalcy." Later, he admitted looking in a dictionary and not finding the word but thought it better than "normality." Nevertheless, normalcy became the theme of his campaign, taking the nation back to the "good old days" before the abnormal period before the war. Harding's running mate, Calvin Coolidge, was the governor of Massachusetts who had called out the National Guard during a strike of policemen in Boston.

Above right: The Democrats nominated Gov. James A. Cox of Ohio and Navy Sec. Franklin D. Roosevelt as his running mate. Unlike Harding campaigning from his front porch in Marion, they spoke to crowds at railroad stations while on a whistle-stop tour of the Middle West. At the same time, baseball was not returning to normalcy. The Reach Company used an improved machine to make baseballs and the dead-ball era came to an end. Babe Ruth of the New York Yankees became the homerun king, but the Cleveland Indians won the World Series in 1920.

Below: On July 22, 1920, the National Woman's Party addressed Harding on his front porch in Marion. According to congressional records, Sen. Harding missed most Senate votes, including the proposal of the amendment giving women the right to vote. With adoption of the Nineteenth Amendment in August, the party would campaign for an Equal Rights Amendment. During the war, the importance of women in the workforce played a major role in the victory over Germany.

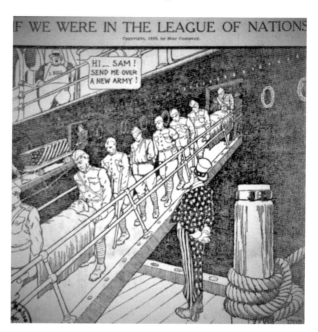

The League of Nations was the dominate issue in the 1920 election between the nationalists of the Republican Party and internationalists of the Democratic Party. How could the country avoid getting involved in another war? Harding's return to normalcy would eventually captivate most of the voters wanting again the nostalgic times before the Great War. Europe should take care of its own problems and not expect help from the United States.

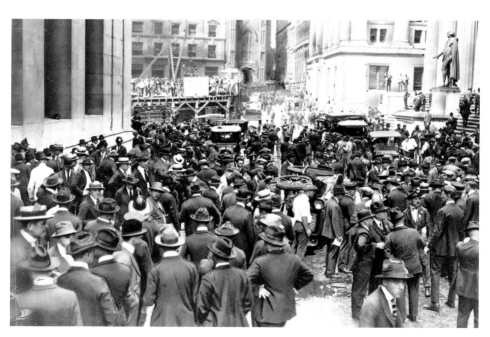

On September 20, 1920, anarchists set off a bomb in front of the J. P. Morgan & Co. office at Broad and Wall Streets in New York. A year earlier, the Justice Department prevented the mailing of bombs to business and political leaders, which included John D. Rockefeller and Atty. Gen. A. Mitchell Palmer. Using the Espionage Act of 1917, Palmer deported aliens suspected of being Bolsheviks and anarchists. The Red Scare subsided by the time Pres. Harding took office.

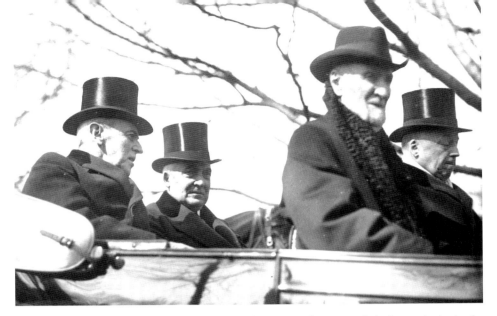

Above: Harding won 60.3 percent of the popular vote and an overwhelming majority in the Electoral College. On inauguration day in March 1921, he rode to the Capitol with Woodrow Wilson at his side. Seated left to right in front of them, Rep. Joseph G. Cannon and Sen. Philander C. Knox both opposed the country joining the League of Nations. Not yet recovered from his stroke, Wilson appeared stoic, surrounded by his political enemies.

Below: Soon after the inauguration, the President's cabinet posed outside of the White House: Left to right in first row: War Sec. John W. Weeks, Treasury Sec. Andrew Mellon, Sec. of State Charles Evans Hughes, Pres. Harding, Vice Pres. Calvin Coolidge, and Navy Sec. Edwin Denby. Second row: Interior Sec. Albert Fall, Postmaster Gen. William H. Hays, Atty. Gen. Harry M. Daugherty, Agriculture Sec. Henry C. Wallace, Commerce Sec. Herbert Hoover, and Labor Sec. James J. Davis. Except for Daugherty and Fall, the appointments proved to be a strength in Harding's administration.

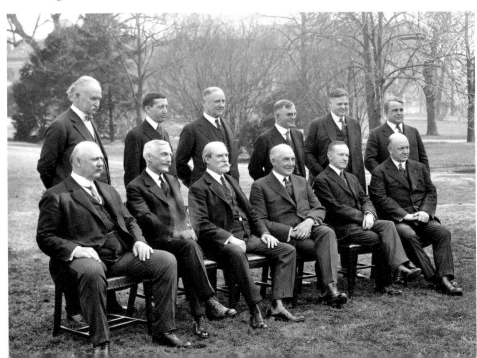

Above: Pres. Harding and Florence Harding visited recuperating veterans at Walter Reed Hospital on March 20, 1921. Over 200,000 Americans suffered wounds in the war. The first school for physical therapy opened at the hospital during the war. The recruitment of women to aid orthopedic surgeons resulted in significant progress in preparing the patients for life in the outside world.

Right: The American Red Cross and other associations were overwhelmed with those in need of help. Wounded in the war, Judge Robert Marx of Cincinnati founded the Disabled American Veterans of the World War. Congress charted the organization on September 25, 1921. For years to come, Marx's association continued to aid disabled veterans.

FACING THE FUTURE

UNCLE SAM OFFERS TRAINING TO
EVERY MAN DISABLED IN THE SERVICE

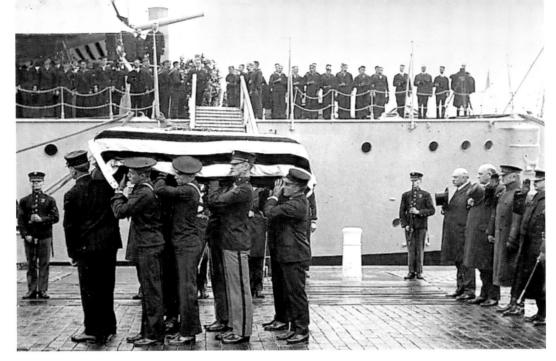

Above: The Unknown Soldier arrived aboard the USS *Olympia* at the Washington Navy Yard on November 9, 1921. Left to right: War Sec. John W. Weeks, Navy Sec. Edwin Denby, Gen. John J. Pershing, and Adm. Robert E. Coontz stood on the wet dock. The following day in the Capitol Rotunda, 90,000 paid their respects. Among the 77,000 killed on the Western Front, over 3,000 were unknown. Nearly 5 million Americans served in the military during the war, and casualties totaled over 320,000. Including deaths from disease, 116,500 died. (*District of Columbia Public Library*)

Below: On Armistice Day, November 11, 1921, Pres. Harding and Gen. Pershing walked in a procession following a caisson with the Unknown Soldier. In spite of the cold and rain, thousands lined the streets. The journey ended in Arlington National Cemetery. The President dedicated the Tomb of the Unknown Soldier; speaking to a crowd that included foreign dignitaries, he honored all those who had died and hoped the nation would avoid any future wars.

On Christmas 1921, Pres. Harding commuted Eugene V. Debs's sentence of ten years in a federal prison for violating the Sedition Act. His arrest followed an anti-war speech outside the Canton, Ohio workhouse on June 16, 1918. Debs supported the actions of his three imprisoned anti-war comrades and the Bolsheviks who had taken Russia out of the war. The perennial Socialist candidate for president ran from his jail cell in 1920 and won almost 4 percent of the popular vote.

Some 15,000 out of the 2 million troops of the American Expeditionary Force continued to occupy the west bank of the Rhine at Koblenz, Germany. Since the Treaty of Versailles had not been ratified, the nation was still technically at war with Germany. Sen. Knox introduced a resolution to make a separate peace in the summer of 1921. America's commitment to Europe ended with the withdrawal of all troops on January 24, 1923.

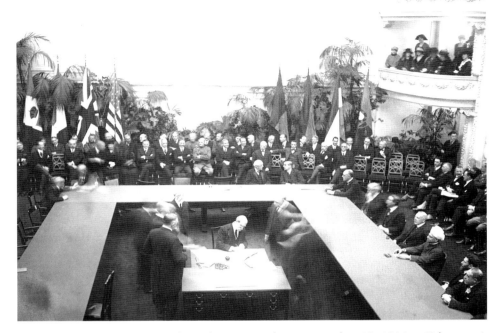

Above: The Washington Naval Conference met from November 12, 1921 to February 6, 1922. In spite of not joining the League of Nations, the United State did not plan to isolate itself from the world. Sec. of State Hughes announced to the delegation that the battleship arms race should end and a limit be placed on the size of each nation's fleet of capital ships. After intense debate over details, the conference agreed to a treaty, which had to be renewed in ten years. The United States, Great Britain, France, and Japan were among the signers.

Below: The Washington Naval Treaty limited the number and tonnage of capital ships. Originally designed as a battle cruiser in 1920, the USS *Saratoga* was the Navy's second aircraft carrier when launched five years later. In the picture during the late 1920s, she was on maneuvers in the Pacific. The ship survived World War II and won eight battle stars. Her sister ship, the USS *Lexington*, sank during the Battle of the Coral Sea in May 1942.

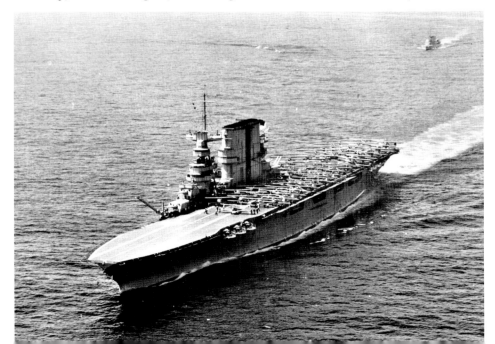

Above: Left to right: Henry Ford, Thomas Edison, Pres. Harding, and Harvey Firestone, Jr. enjoyed the Florida weather in 1921. The three businessmen often vacationed together, calling their group the Millionaire's Club. The scene was symbolic of the alliance between government and business after the Wilson years of new anti-trust laws to regulate the economy. Treasury Sec. Mellon's income tax reform mostly favored the upper classes.

Below: Prohibition began nationally on January 1, 1920 after the ratification of the Eighteenth Amendment the previous year. Congress then passed the Volstead Act to clarify a law that became difficult to enforce. Organized crime flourished with the bootlegging during the decade. Proprietors of speakeasies defied the law and bribed police officials. As a member of the Senate, Harding had supported prohibition. Hypocritically, he served alcoholic drinks in the White House. Many members of Congress and government officials also violated the law.

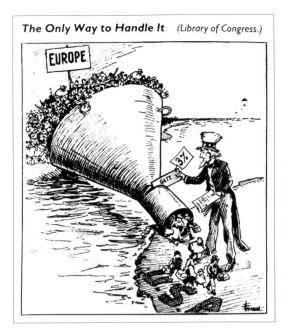

The Only Way to Handle It (Library of Congress.)

Some 70 percent of the immigration in the decade prior to the war came from Eastern and Southern Europe. The census of 1920 showed that almost 15 percent of the nation's population had been born in this region. Critics claimed that these people did not assimilate well into the melting pot of American society. The Immigration Act of 1921 became the first law to restrict the number of Europeans coming to America. The act favored immigrants from northern and western Europe.

During World War I, aliens in the country, especially those from belligerent nations, were encouraged to take Americanization classes and learn English. Citizenship became the next step in the assimilation of those born overseas. After the war, some did return to their homelands but most stayed in spite of the prejudice against them. They lived in ethnic neighborhoods, which were transplants of villages in the Old World. Assimilation would come easier for their children.

Above: The Ku Klux Klan enjoyed a revival before the war, portraying itself as a political and not a terrorist group. Klansmen paraded in Washington during the 1920s. Membership increased in the South and the North with Indiana having the largest enrolment in the nation. The Klan expanded its traditional hatred of African Americans to Jews and Catholics besides Eastern and Southern European immigrants. Its agenda favored rural small-town America, the domain of White Anglo Saxon Protestants. The federal census of 1920 showed most people now lived in cities, which the Klan saw, except for the South, as the home of the enemy. Membership soon declined as financial scandals and lynching tarnished its image in the North.

Below: Chief Justice William Howard Taft and Pres. Harding took part in dedicating the Lincoln Memorial in 1922. Robert Todd Lincoln, the martyred president's son, stands on the far right. A successful corporate lawyer, he served as Secretary of War under Garfield and Arthur then ambassador to England for Benjamin Harrison. He witnessed the shooting of Garfield and attended the Pan American Exposition, the setting of McKinley's assassination in Buffalo. During GOP conventions from 1884 to 1912, Lincoln refused to have his name placed in nomination for president or vice president.

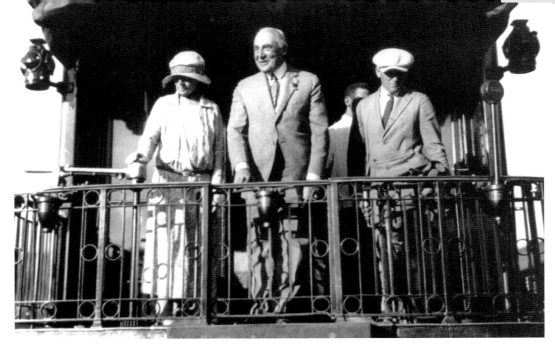

Above: A year later, Pres. Harding had aged considerably. In June 1923, Warren and Florence Harding boarded a train in Washington for a tour of the western United States, Alaska, and Canada. The President's health had deteriorated after being sick from influenza in January. Stressed over the reports of scandals, Harding's heart problems were aggravated by over eating, drinking, and smoking. He became even more fatigued from the busy schedule of speeches and personal appearances. In San Francisco, he came down with pneumonia and died at the age of fifty-seven years from a heart attack on August 2, 1923.

Below: A memorial service for Harding took place in the House of Representatives on February 27, 1924. Charles Evans Hughes gave the eulogy. Dignitaries in the first row included from left to right: Herbert Hoover, Henry C. Wallace, Hubert Work, Edwin Denby, Harry S. New, Harry M. Daugherty, John W. Weeks, Andrew Mellon, Calvin Coolidge, and William Howard Taft.

Above: In spite of criticism, Pres. Harding had chosen Daugherty as his Attorney General for being a successful campaign manager. Forced to resign by Pres. Coolidge, Daugherty faced charges of corruption in office but was never found guilty. Ohioans in a number of agencies betrayed the president's trust in them. The former Secretary of the Interior, Albert Fall, became the first cabinet member in history sentenced to prison. Harry F. Sinclair and Edward L. Doheny, oilmen and friends, bribed Sec. Fall to give them access to the naval reserves at Elk Hills in California and Teapot Dome in Wyoming, seen today in the picture.

Below: At the time of his death, Harding was a very popular president, which accounted for his impressive memorial built in Marion with money donated by thousands of mourners. The scandals in Washington delayed by four years the official dedication until the Great Depression became the focus of the nation's concerns. On June 16, 1931, Pres. Herbert Hoover spoke at the monument and avoided mentioning the scandals.

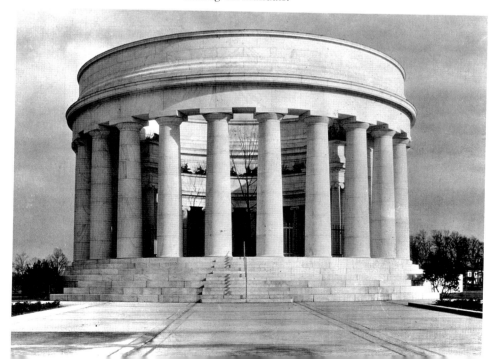

Bibliography

Barnard, H., *Rutherford B. Hayes, and His America* (New York: Bobs-Merrill,1954)

Brands, H. W., *TR, The Last Romantic* (New York: Harper Collins, 1997)

Calhoun, C. W., *Benjamin Harrison* (New York: Times Books, 2005)

Collins, G., *William Henry Harrison* (New York: Times Books, 2012)

Dean, J. W., *Warren G. Harding* (New York: Times Books, 2004)

Gould, L. L., *Presidency of William McKinley* (Lawrence: Regents Press of Kansas, 1980)

Leech, M., *In the Days of McKinley* (New York: Harper, 1959)

McFeeley, W. S., *Grant: A Biography* (New York: W. W. Norton & Company, 1981)

Millard, C., *Destiny of the Republic: A Tale of Madness, Medicine, and the Murder of a President* (New York: Anchor Books, 2011)

Peskin, A., *Garfield, A Biography* (Kent: Kent State University Press, 1978)

Rosen, J., *William Howard Taft* (New York: Times Books, 2018)

Russell, F., *The Shadow of Blooming Grove: Warren G. Harding in His Times* (New York: McGraw-Hill, 1968)

Schlesinger, A. M., *Age of Jackson* (Boston, New York, London: Little, Brown and Company, 1946)

Sievers, H. J., *Benjamin Harrison: Hoosier Statesman* (Newton, Conn.: American Political Biography Press, 1971)

Smith, J. E., *Grant* (New York: Simon & Schuster, 2002)

Trefousse, H., *Rutherford B. Hayes* (New York: Times Books, 2002)